OIL PASTEL

for the SERIOUS BEGINNER

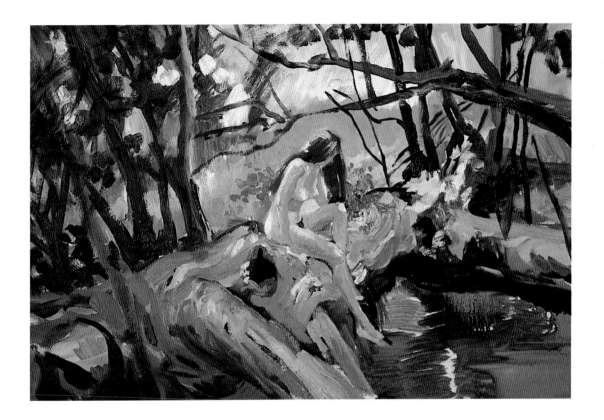

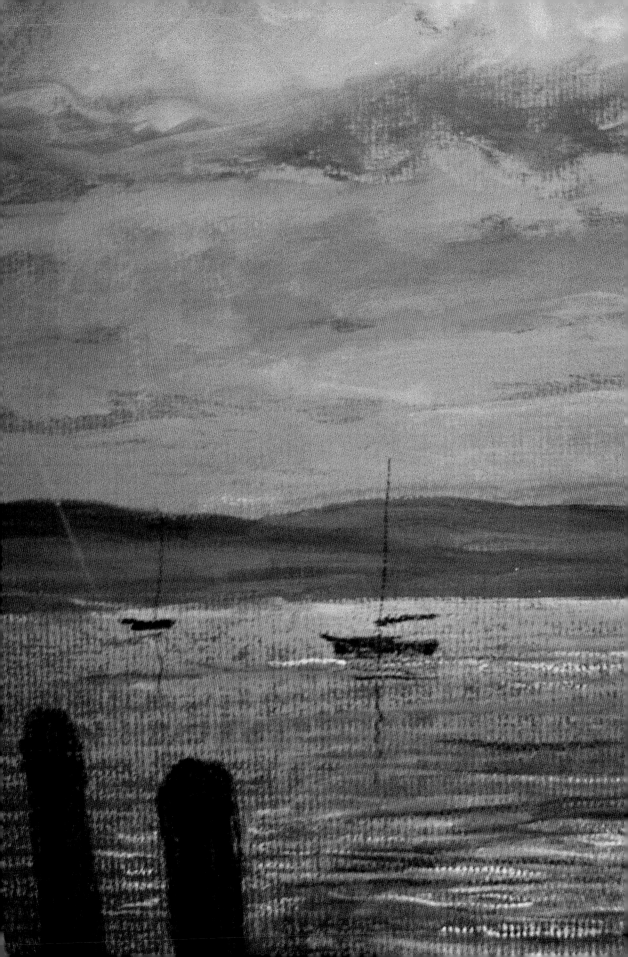

OIL PASTEL

for the SERIOUS BEGINNER

John Elliot

with Sheila Elliot

WATSON-GUPTILL PUBLICATIONS / NEW YORK

*This book is dedicated to all artists
who are ready to explore oil pastels.*

Cover
FLORAL FIREWORKS
Oil pastel on metal plate, 36 × 24" (92 × 61 cm).

Frontispiece
SHEILA IN THE WOODS
Oil paint over oil pastel on canvas, 20 × 24" (51 × 61 cm).

Title spread
HUDSON RIVER FROM PETERSEN'S BOATYARD
Oil pastel on pastel paper, 16 × 20" (41 × 51 cm).

Artwork throughout the book in private and corporate collections.

Acquisitions Editor: Candace Raney
Edited by Robbie Capp
Designed by Areta Buk
Graphic production by Ellen Greene
Text set in Adobe Garamond

Copyright © 2002 John Elliot

First published in 2002 by
Watson-Guptill Publications,
a division of VNU Business Media, Inc.
770 Broadway, New York, NY 10003
www.wgpub.com

Library of Congress Control Number: 2002102706

ISBN:0-8230-3311-2

All rights reserved. No part of this publication may be reproduced or used in any form or by any means—graphic, electronic, or mechanical, including photocopy, recording, taping, or information storage and retrieval systems—without written permission of the publisher.

Printed in China

First printing 2002

3 4 5 6 7 8 / 09 08 07 06

ACKNOWLEDGMENTS
We would like to extend a heartfelt tribute to Peter Hopper, founder of Holbein. Peter brought the first artist-quality oil pastels to this country and persevered through thirty-five years of struggle to make this wonderful new material available to the creative artist. Without his vision and strength of purpose, we would not be here writing this book. To a true pioneer, we remain indebted.

Our thanks to Dorothy Coleman, without whose ESP this book would not have happened; to Tim Hopper, whose encouragement and support made this book possible; to Pierre Guidetti, for his interest in the project; to our son, Gil, who freely lent his writing skills to the cleanup of innumerable drafts; to Candace Raney, the acquisitions editor whose insights moved this project to its conclusion; to Robbie Capp, whose editing and layout skills were invaluable; to Areta Buk, for her fine design of this book. We are also grateful to each other—we who started out as a creative producer-designer and screenwriter team, and thirty-five years later, remain a solid and enthusiastic veteran artist-writer team.

Contents

Foreword

Although artist-quality oil pastels are an invention of the twentieth century, the use of wax-based coloring materials dates back to the ancient Egyptians. The appearance of the fine-art medium known as oil pastels did not occur until the mid twentieth century, a direct result of the collaboration between two creative forces—the artist who paints with the materials and the artist who creates these materials.

My grandfather Gustave Sennelier opened the doors of the Maison Sennelier in Paris in 1887. Our store faces the Louvre on the Left Bank, just around the corner from the École des Beaux Arts. The passing of two centuries has seen clients like Cézanne, Gauguin, Monet, Bonnard, Soutine, Modigliani, Kandinsky, and Dali pass through our doors as "regulars" to buy their hand-crafted art materials. Gustave's son and my father, Henri Sennelier, took over the reins of the family business, and as the head chemist at Sennelier, it was my father whom Pablo Picasso came to visit in the 1940s to request a new drawing material that was to become the oil pastel.

Picasso at this time was the leading voice in the artistic movement toward complete freedom of the painterly gesture. He felt inhibited by the traditional materials of oil painting, and longed to express himself without having to adhere to the physical rules and restrictions of painting on primed canvas with oils. The technical and physical limitations of oil paint and other traditional mediums were restrictive as to where and how he could apply his colorful visions. Picasso was famous for drawing on any surface at any time (restaurant bars, wood walls, glass, placemats, etc.) and desired a color medium of true artists' quality for his spontaneous creativity that could be used on a variety of surfaces without fading or cracking. Aesthetically, he required this new material to express the pure essence of the artist's gesture, in an uncompromised intensity of color and texture. Henri Sennelier's response to Picasso's request was the "pastel à l'huile"—the oil pastel—created with the same pigments used in Sennelier's famous oil paints, combined with a pure, acid-free binder made from a proprietary formula of microcrystalline petroleum wax and nondrying chemically inert oils. The oil pastel was Picasso's "holy grail"—a true artists' quality multimedia painting material that had the color intensity and texture of oil paint, without the drawback of oil paint's acidity and cracking that prohibited him from painting on any surface he liked. My father's original formula and range of forty-eight colors developed for Picasso in 1948 remain unchanged to this day. The unusually large number of grays in the range is due to Picasso's specific demand for subtle nuances in gray scales, and he personally created and fine-tuned these hues. Subsequently, artists discovered my father's new medium, and he began to make them available in his store. Artists fell in love with oil pastel's particularly sensual qualities, its vibrant and pure color, with a creamy touch that is described as "satin velvet," akin to drawing with lipstick.

In a sense, we can call the oil pastel a true landmark in twentieth-century art history, because historically, the development and widespread use of a completely new color medium is a rare occurrence indeed. The technical characteristics of the oil pastel offer the artist a new freedom in pictorial expression. I spent twenty years with my father, learning and absorbing his vast knowledge in the art of crafting fine art materials. My legacy to his beautiful range of oil pastels was to increase the number of colors from 48 to 105, including new modern pigments as well as introducing the first archival iridescent colors in a fine art medium.

I would like to thank the author of this book, John Elliot, for his dedication to this art material. The years of his research contained in this book will allow you to discover a whole new world of applications and techniques with oil pastel. His technical knowledge and advice regarding the materials will be invaluable assistance in helping you realize your artistic inspiration.

I consider oil pastelists to be artistic pioneers, in that there is no real history or accepted rules regarding techniques and aesthetics. The oil pastel allows you to create with total freedom, and it is you who will teach and show us the potential of this wonderful medium. Like my father before me, I look forward to collaborating with all the new Picassos, who will astonish us with oil pastel's unlimited possibilities.

Dominique Sennelier
Paris, 2002

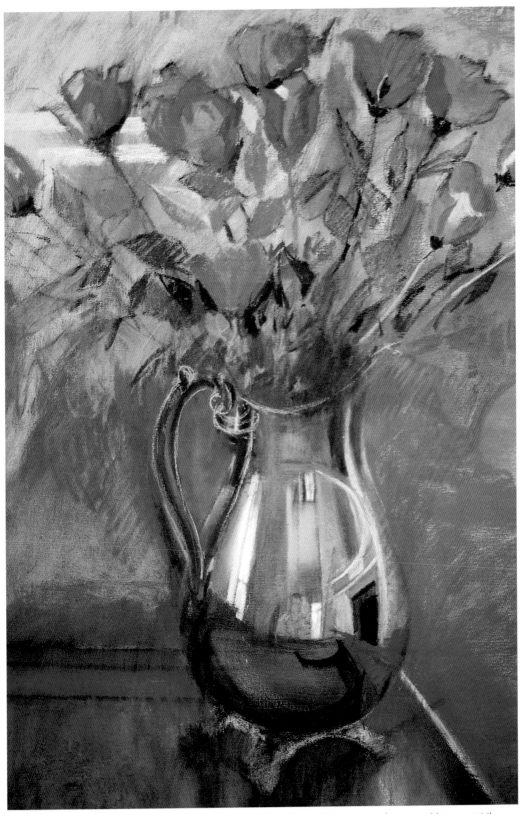

ROSES FOR REFLECTION
Oil pastel on canvas,
28 × 20" (71 × 51 cm).

In this still life, I used blending techniques to soften everything except the roses themselves, so that the flowers would stand out as the focal point of the painting.

Introduction

This book will empower you to paint with oil pastels. You will learn how to create paintings that look like traditional dry pastel works while avoiding the danger—thanks to the nature of oil pastels—of the finished painting dusting off. You will also learn about the excellent archival qualities of oil pastel and how to keep your paintings fresh and beautiful over a long period of time. And you will learn how to combine oil pastel with dry pastel in the same painting for unusual effects, how to use oil pastel as a mixed-media component, with solvents, for printmaking, and other special techniques.

In fact, this book will provide you with everything you need to know to become an accomplished oil pastelist. Step-by-step demonstrations on still life, landscape, portraits, and figures will arm you with all the skills needed to be successful right from the start. And most of all, these pages will save you from having to reinvent what I have learned about using pastels over the past seventy years. Yes—I made my first pastel drawing that long ago, when I was just four years old, and have spent all my years since exploring the medium. And for the last several decades, I have especially delighted in expressing my artistic vision with oil pastels.

Before I began using oil pastels, I had long been aware that great artists throughout the centuries who had worked with traditional pastels always grappled with the problem of keeping pigment dust from falling off of their finished paintings. Sometimes they applied fixatives to their work, but those liquids changed colors in their paintings and could even ruin an entire work. Several early masters experimented with pastel binders, culminating in an almost bizarre medium used by Edgar Degas in some of his pastel paintings. As I learned more about the problem and experienced it in my own work, I was determined to be on the lookout for improvements in the pastel medium itself. They finally came about with the numerous breakthrough technologies in materials science, from which pastels greatly benefited.

Beginning in the mid-twentieth century, a few manufacturers developed more stabilizing binders for pastels. Some innovators dubbed their versions "oil pastels." The name was not totally accurate, as these products actually utilized a multicomponent binder that included inert wax and oil. Today, each manufacturer of oil pastels uses its own binder formula. But what they all have in common is a dustless pastel that does not require the use of risky and damaging spray fixatives. The oil pastel binder also does away with dust flying in the air around the studio. Pastelists who had to give up dry pastel for health reasons, myself included, can now return to their well-loved medium just by switching to oil pastels.

As these new pastel materials were being developed and refined, I enthusiastically experimented with them, trying traditional pastel techniques and then pushing the envelope to see what else the newly formulated oil pastels could do. Ever since, through workshops, demonstrations, and many articles that I've written for trade publications, I have been devoted to spreading the word about the glories of oil pastel to students, professional artists, and art collectors.

As a culmination of my contributions to the field, in this new millennium, I now challenge the art community and manufacturers to change the name of "oil pastels" to a more accurate designation. Following the logic of Leonardo da Vinci, who named early pastels "dry pastels," why shouldn't we artists refer to so-called "oil pastels" as "dust-free pastels"? After you learn about this marvelous medium and how to use it, I encourage you to think about oil pastels by their more accurate name: *dust-free pastels.*

Finally, I hope that you will cherish, as I do, each of your excursions into creativity with this exciting medium—and as you journey through these pages with me, I wish you happy painting!

PORTRAIT OF FAITH
Oil pastel on museum board, 30 × 24" (76 × 61 cm).
This painting shows a high degree of finish, with the pastel pigment applied very opaquely. A versatile medium, oil pastels can also be applied very openly, with lots of surface showing through.

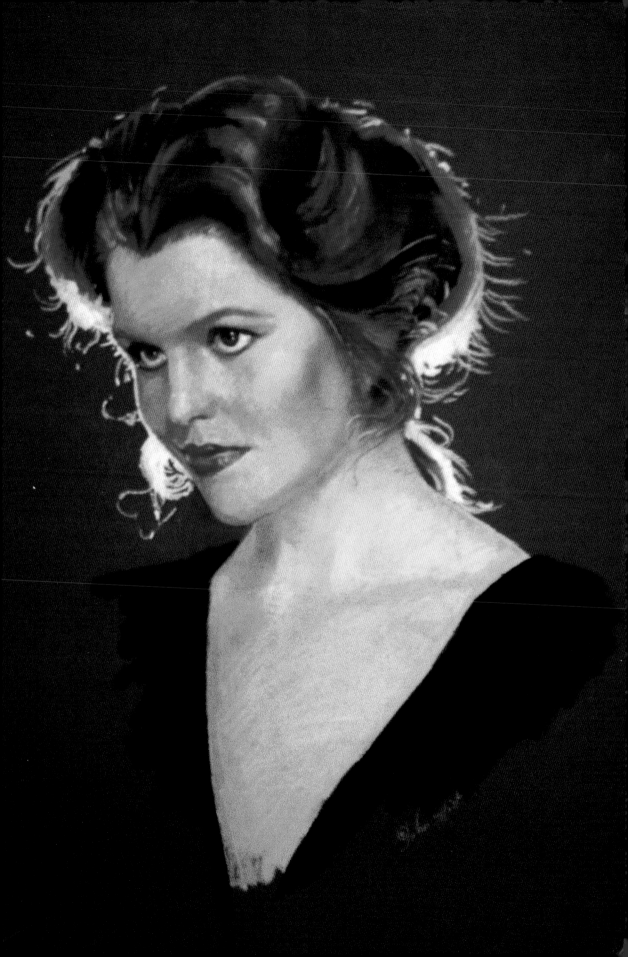

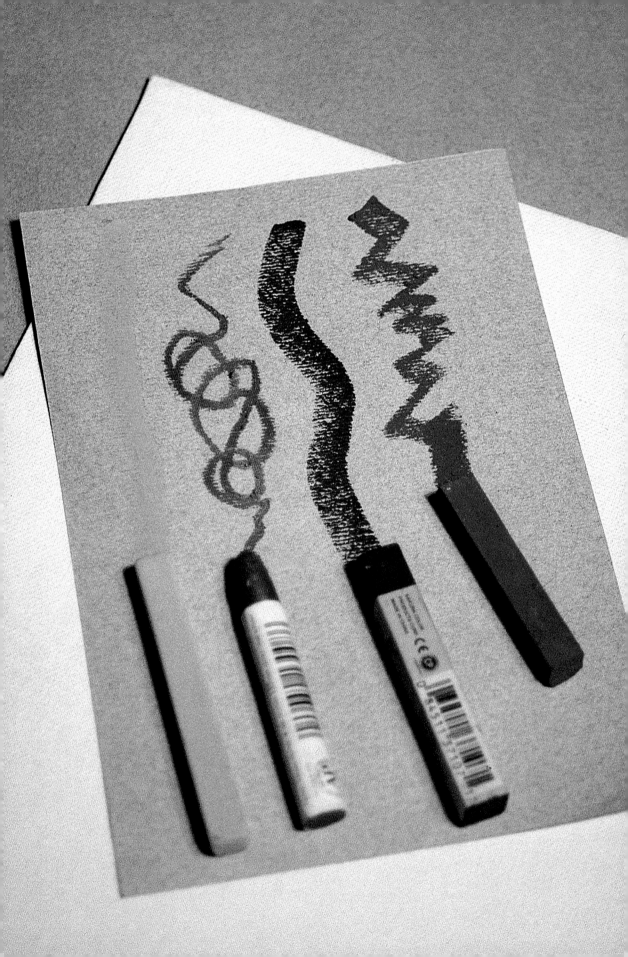

Materials

The generic definition of *pastel* is a stick of ground pigment mixed with just enough binder to keep its shape. *Oil* pastels are pastels that have ground pigments combined with a slight amount of wax, softened with a smaller amount of oil; in professional-grade formulas, it's acid-free oil that gives the product its archival, or long-lasting, quality. Compared with traditional "dry" pastels, oil pastels are not chalky or powdery to the touch; they are dust-free.

Oil pastels range from the Sennelier soft sticks to the Holbein and Cray-Pas Specialist medium-hard sticks. Regardless of brand, oil pastel can be rubbed onto virtually any surface, even slick ones that have practically no "tooth"—that is, the rough surface required for dry-pastel application. Since their pigments stay put and will not dust off, oil pastels do not contaminate the atmosphere, so wearing a nose/mouth mask and vacuuming is not needed, as it might be when using dry pastels.

Note that oil pastels should not be confused with oil *sticks*—an oil *paint* that comes in stick form. Like any other oil paint, oil sticks create a hard outer skin. By contrast, an oil pastel painting will harden slightly over time, but never forms a hard outer skin. Applied with basic pastel techniques, it remains forever somewhat workable. Therefore, oil pastel paintings should not be varnished, but should be framed to prevent accidental scratching or smudging. (For framing tips, see page 136.)

Oil pastels come in square and cylindrical sticks, wrapped and bare, some soft and creamy, others of a harder consistency. A spiral-bound pastel pad is a practical paper choice for the beginner. There are also loose sheets of pastel paper offered in many colors, and other supports, such as museum board and canvas panels, are also good surfaces for oil pastel painting.

Choosing Oil Pastels

While this book is intended for newcomers to the medium of oil pastel, as a serious beginner, you should select fine-quality artists' materials. If you economize by purchasing student-grade material, it will probably have nonarchival binders and fillers that are colored with fugitive dyes that fade easily. With these you will struggle unnecessarily, and eventually lose the painting you worked so hard to create.

I use all brands of oil pastel and always keep my eye out for new professional-level products. As demand for artist-quality oil pastels grows, I expect more and more brands to become available. As a pastelist, you will learn that collecting as many sticks as possible enables you to paint with the widest selection of hue and value gradation. You won't be frustrated by needing that great color you didn't buy last week. You can even put oil pastels on your "wish list" and have the fun of opening gifts that will give you hours of painting pleasure.

Since each of the leading brands of oil pastel has its own characteristics, the following profiles will help you determine which ones you'd like to try first. They will all be found at fine art supply stores. If your local retailers do not have just what you want, the manufacturers can be contacted directly (see "Resources," page 142).

The 225-color set made by Holbein comes in a wooden box that has three trays. Quality is controlled through an automated process, so that the full range of oil pastels is uniform in quality, color, and handling characteristics from one production run to another. All colors are rated for lightfastness and have been aligned with the Munsell Color System, which allows the artist to compare hue, value, and chromas by a standardized format.

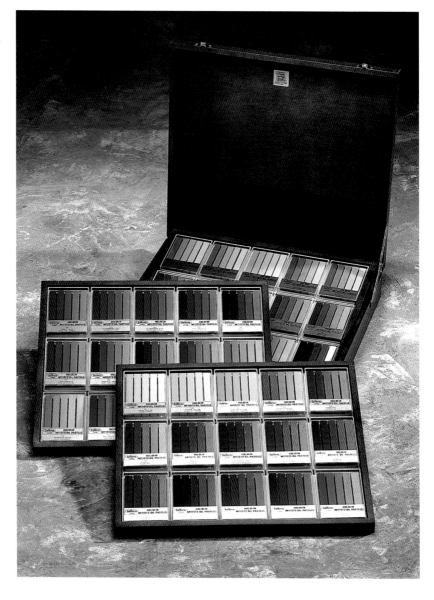

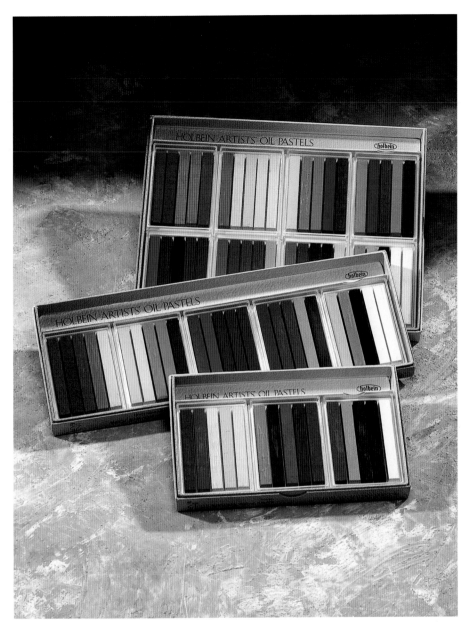

Among the smaller sets of oil pastel offered by Holbein are these assortments of 15, 25, and 40 colors. They come in cardboard boxes—compact and lightweight alternatives for the landscape painter working on location.

HOLBEIN

I consider one of the best oil pastel sets to be the Holbein wooden case of 225 brilliant colors, offered in a dazzling array of gradations. Created in 1960 in Japan, Holbein sticks are square, of medium hardness, and have an acid-free, nontoxic, archival quality. They were the first oil pastels to come to the American market. When I discovered the brand shortly after their introduction here about two decades ago, it did not take me long to realize this was going to be a great medium for my paintings. I was so enthusiastic over the product that I wrote the first article about oil pastels, which appeared in *American Artist* magazine in 1983, and have been extolling their qualities ever since.

SENNELIER

Sennelier has been the leading family-run manufacturer of art materials in Europe for more than a century. Established in 1887, the firm's products quickly became favorites among the French Impressionists. About fifty years later, Pablo Picasso asked Sennelier to create a completely new medium that had the qualities of oil paint combined in a stick form that could be applied to the many surfaces Picasso worked on at the time—paper, canvas, glass, metal—without having to prepare or prime the surface. In addition, he asked that the colors be vibrant and lush, without ever yellowing, fading, or cracking.

The colors in this original set of oil pastels, created for Picasso, were tested and approved by the master himself.

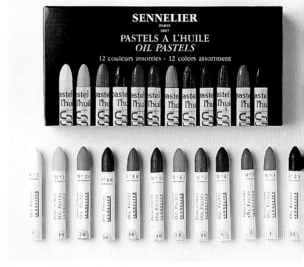

This set of 12 Sennelier oil pastel sticks is a handy choice for the artist working on location. Known for their smooth handling characteristics, these round sticks with pointed ends can be painted on unprimed surfaces such as paper, canvas, or wood.

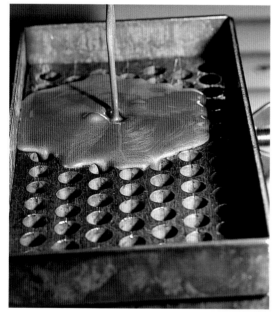

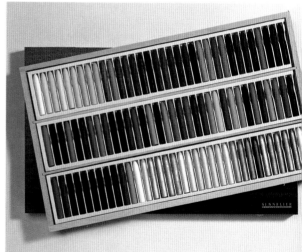

This complete, 102-stick selection contains Sennelier's balanced range of traditional and nontraditional colors. The traditional, lightfast colors are opaque, semi-transparent, and transparent. The nontraditional colors, such as iridescents, can be mixed with traditional hues to achieve light-reflecting effects. All colors are lightfast and permanent, including the metallics and fluorescents.

Two steps in the production of Sennelier oil pastels.

After two years of experimentation, in 1948, Sennelier unveiled the first artist-quality oil pastels: sticks of color pigment, wax, and oil. The stick applied as creamily as lipstick, but held its shape. Many of the grays—cool and warm, with casts of lavender, blue, and rose—were developed specifically at Picasso's request. Still produced in France, the Sennelier brand is imported to the United States by the distributor Savoir-Faire.

The Sennelier line of oil pastels has grown from its original palette of 48 colors to 105, which includes some iridescent, fluorescent, and metallic hues. The company also makes a "giant" oil pastel stick (over an inch in diameter) that is the equivalent of 18 traditional-size sticks, created especially for Frank Stella for his large-format abstract works. It comes in a set of 48 (which looks a lot like the company's set of giant soft pastels, so be careful to read labels before buying).

CRAY-PAS

Don't confuse Specialist Cray-Pas (a contraction of *crayon-pastel*) with Crayola, that children's crayon that comes in those ubiquitous little yellow boxes.

The Specialist brand artist-quality product is manufactured by Sakura and is imported from China. Cray-Pas Specialist is a fine oil pastel offered in a set of 50 sticks with artist-quality characteristics, including lightfastness. The sticks are medium-hard and include two metallics: gold and silver.

WATERSOLUBLE OIL PASTELS

Watersoluble oil pastels are as dust-free and self-fixing as regular oil pastels, but, being soluble with water, this product doesn't require solvents (petroluem distillate or gum resin) to produce a wash technique. You simply use water and a brush to spread the oil pastel pigment when you want your painting to have a wash look about it.

So far, the only such product on the market is the Portfolio brand—a set of 24 colors made by Binney-Smith (the Crayola manufacturer), but it's geared toward the junior high and high school market. I like how the sticks behave, but wish manufacturers would come out with a version up to artist-quality standards, because the watersoluble aspect obviates the use of toxic solvents for wash techniques.

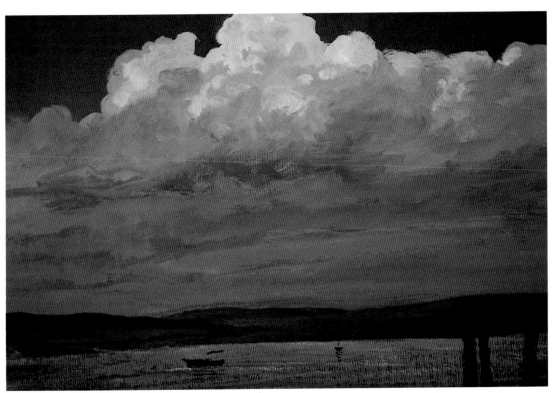

HUDSON RIVER CLOUDS SERIES, II.
Oil pastel and watersoluble oil on museum board, 14 × 16" (36 × 41 cm).

Oil pastel is the perfect medium for expressing fluffy, opaque clouds like these.

Painting Surfaces

Artist-quality oil pastel can go on virtually any surface: primed or unprimed, toothed or smooth. You can paint on tinted pastel papers or sturdy white watercolor papers; paperboards, hardboards, and the new pastel boards; canvas and fabrics; even wood, metal, and glass. As you get more confident and experimental, you are limited only by your imagination. Just make sure that your surface is sturdy enough to take blending, scraping, and vigorous manipulation of oil pastel.

As with your selection of oil pastels, try to select only archival-quality painting surfaces. The terms *acid-free, pH neutral,* and *100-% rag* are used to identify such painting surfaces. As you develop from a beginner to a more experienced oil pastel artist, check manufacturers' specifications and permanence ratings for papers in the same way that you research your oil pastels. Professional artists even contact conservation departments of nearby museums to seek advice about materials. Some curators will give verbal advice, even though museum policies preclude written statements.

PAPER
Of the many art papers available, two that were specially designed for oil pastel work are the Strathmore 403 series and the Holbein Sabre-Tooth. You can also apply oil pastels to tinted paper designed for dry pastel, such as Mi-Teintes by Canson. White watercolor papers are also excellent, especially when you purchase them in block form. It's like having a built-in drawing board; you can work without backing the paper against a support.

Try applying oil pastels to handmade papers, printmaking papers, and other unusual papers. Mount any paper you use on a drawing board that has a few sheets of newsprint attached to it. The drawing board provides a sturdy surface to paint on, and the newsprint gives a slight cushion to your chosen paper.

MAT BOARD, MUSEUM BOARD
You can use boards as an alternative to paper. Crescent Museum and Bainbridge Alpha mat boards are archival quality. Avoid ordinary mat boards, as these are neither acid-free nor lightfast and can fade over time. Since some of the paper will show through and optically mix with pastel pigments in most paintings, your optical mixtures will degrade over time if you don't select a lightfast surface. You certainly don't want your finished painting to change color after it's hung with pride in your home or someone else's.

RIGID SURFACES
Pastelbord, made by Ampersand, is an archival-quality panel completely sealed with acrylic polymer gesso, coated with fine clay, and finished with marble dust. The superb quality of these boards has taken pastelists by storm, and because of the board's strength and rigidity, pastelists can dispense with a drawing board when painting on this surface.

Oil pastel even works well on ordinary hardboard, such as Masonite. Note, however, that when purchasing hardboard, you cannot be sure of archival status since hardboard is not branded on the surface. This means you usually cannot check with the manufacturer to identify your hardboard's component materials and archival status. For this reason, many artists seal the front and back surfaces with acrylic gesso before starting a painting.

Though not always of archival quality, canvas boards are widely available, inexpensive, and easy to transport when working on location. Generally used by oil painters, these boards come in small and large sizes, and beginners particularly find them handy for studies and exercises, as well as finished work.

CLOTH
Canvas and various other fabrics are suitable surfaces for oil pastels. Depending on the effect you want, you can select either primed or unprimed canvas. Primed will give a harder base on which to apply oil pastel and will enable much of the canvas to peek through your layers of pigment. Unprimed canvas has a softer surface. You will be able to press more oil pastel into the spaces between the threads. In contrast to liquid paint, oil pastel will sink in very little on unprimed canvas.

If you put your canvas on stretchers, you may want to use a backing board, such as a sheet of Fome-Cor behind the canvas if the springiness of the stretched canvas (desirable for brush painting) bothers you when applying oil pastel. An alternative to stretching is taping or clipping your canvas to a drawing board, and dispense with stretchers altogether. Because oil pastel is not a liquid medium, you don't need to stretch the canvas or worry about it buckling with moisture. You just need to keep it flat and uncreased.

Various other fabrics are also suitable for oil pastel paintings. Select among the 100-percent natural linens and cottons for proven strength and longevity. Avoid super-fine silks and heavy burlaps, even though you could use them for special-effect works.

Offered in four different colors, Pastelbord is $\frac{1}{8}$" thick, and comes in ten sizes, from 5 × 7" up to 30 × 40". The surface is pH neutral and acid-free, and takes oil pastel beautifully. Applied to archival surfaces, pigment colors stay fresh and clean indefinitely.

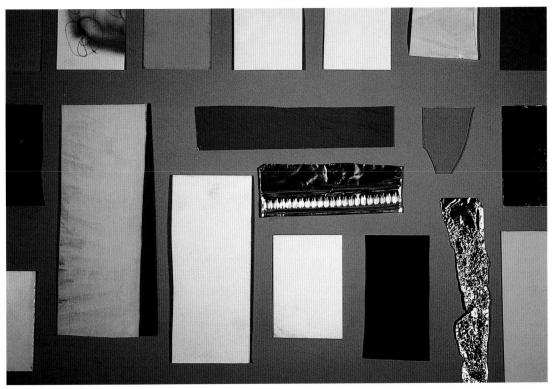

Oil pastel can be applied to almost any surface. For example, left to right, top row: brown alpha board; watercolor paper spray painted (a discard); primed blue illustration board; velour paper; watercolor paper; rice paper; medium-charcoal pastel paper. Center row: dark-charcoal pastel paper; canvas (vertical) panel; green sabertooth paper; clear glass; metallic board. Bottom row: sanded paper; white illustration board; metal foil tray; high-gloss card stock, white and black; aluminum foil; buff printing stock.

Other Useful Materials

Besides oil pastels and painting surfaces, you will need a short list of readily available materials for studio work. For painting on location, there are additional supplies to be considered, which we'll get to in Chapter 3, devoted to landscape work.

STUMPS, TORTILLONS

These rolled paper tools are great for blending and spreading oil pastel. Both are cigar-shaped. Stumps are about six inches long and have a point at each end; tortillons are usually shorter, with a point at one end only. I also use paper towels for blending.

CUTTING TOOLS

You will need a single-edged razor blade and a few other cutting tools. The razor is for cutting sharp edges on your pastel sticks when you need them for small detail work; the wide side of the razor is useful for scraping down an area of oil pastel, either for an artistic effect or prior to correction.

Etching tools are also useful, but if you don't own any, you can improvise with household implements such as a penknife, metal nail file, or even a small, flat-ended screwdriver. All of these are good for etching details. Note that a standard art knife is too sharp and pointed for etching out details. It's far too easy to scratch or cut through the paper inadvertently if your tool is surgically sharp.

COLORED PENCILS, CHINA MARKERS

Both can be used to create fine details on oil pastel paintings. I prefer colored pencils, such as Prismacolor, for detail work. They come in a very wide assortment of colors that coordinate with and/or complement an oil pastel palette. China markers—those waxy pencils with peel-off paper casings—tend to lose their points quickly, and are available in a limited range of colors.

ERASERS

While soft, kneaded erasers work for dry pastel, unfortunately, they won't work for oil pastel. An electric eraser is what I find to be most effective.

I not only erase prior to making corrections, but I occasionally use an electric eraser selectively for painting—such as to lighten an edge.

There are a few kinds of electric erasers on the market. My choice is the Kohinoor, which has a rechargeable battery. There is also a battery-operated electric eraser made by Sakura. Another rechargeable version is made by Staedtler. But before investing in an electric eraser, you might try Pentel's manual Clic Eraser (looks like a pen). It won't erase as thoroughly as an electric tool, but good enough to allow painting over an erased area when a correction is needed.

CLEANUP SUPPLIES

Keep a good supply of paper towels on hand for wiping your fingers, to keep pastels clean, and for blending. I like a brand that is sturdy, yet soft, such as Bounty towels. On location and for more serious cleanup, I also carry a small packet of moist wipes in a recloseable plastic bag.

MATERIALS FOR SOLVENT TECHNIQUES

Later in this book (Chapter 5), you'll learn about some unusual solvent techniques, and I hope you'll want to add them to your pastel skills. If you do, you will need to add paint brushes (both bristle and the softer wash types), sponges, and a spray container to your basic supplies.

As for solvents, until such time as professional watersoluble oil pastels come to the market to be used for permanent work, I am forced to use petroleum distillate solvents to create special techniques that produce washlike effects. The solvent I find most effective for this purpose is Weber's Turpenoid, which has somewhat less of an odor than most other solvents.

Although environmentally friendly and citrus-based formulas are available, they are all toxic. Therefore, all chemical solvents should be used with good ventilation, protective gloves, and a good scrub-down afterward.

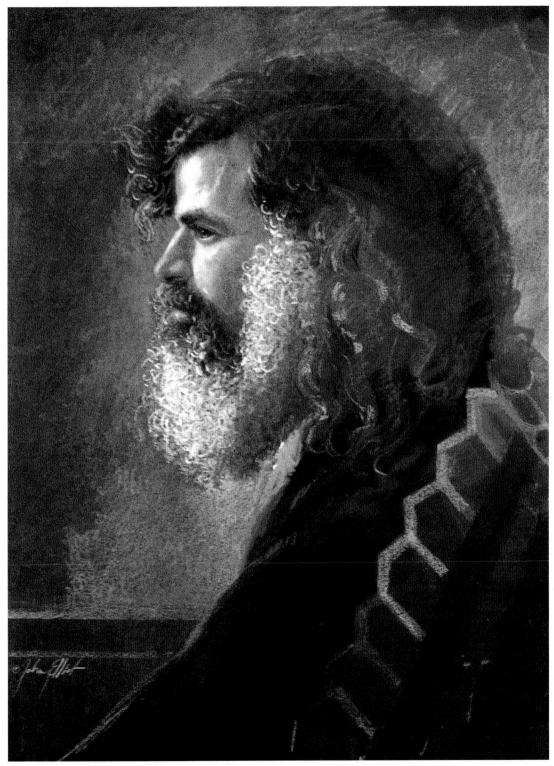

THE ARTIST
Oil pastel on pastel paper,
36 × 30" (92 × 76 cm).

This was a demo I did for my class on portrait painting in oil pastel. One of the artists volunteered to model, and I painted his portrait over several sessions. Because the medium was oil pastel, which is so easy and safe to transport, I had no trouble carrying it back and forth to the classroom.

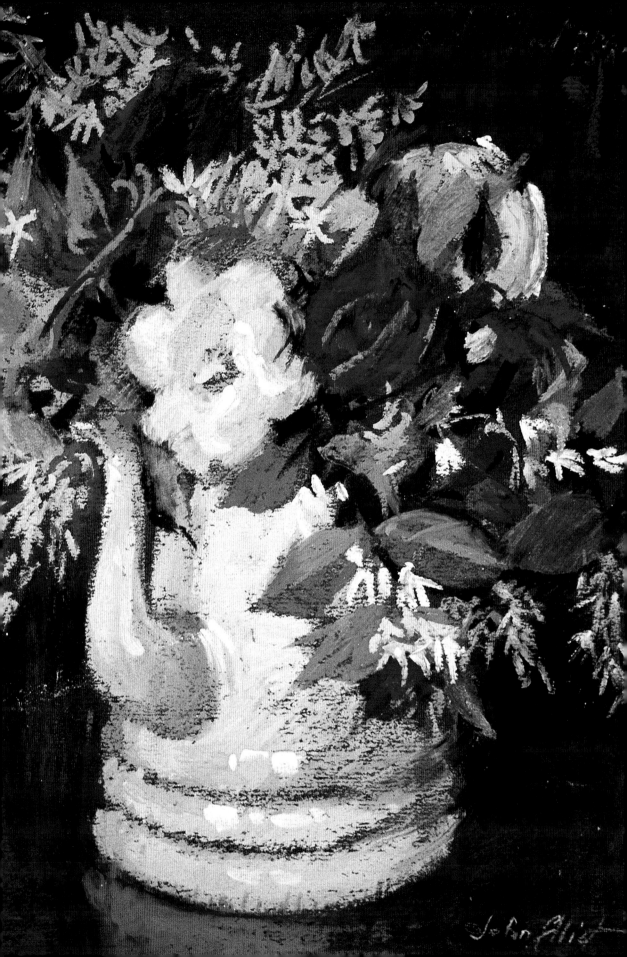

Still Life

Even if you've never painted in this medium before, by the end of this chapter, you will be able to create a credible oil pastel still life, from start to finish. Here are the essentials that will be covered:

- Making basic marks
- Laying color on color
- Blending
- Detailing
- Correcting
- Putting it all together: step-by-step still-life demonstration
- Deciding when your painting is finished

But first, let's warm up. Athletes warm up. Ballerinas warm up. Musicians warm up by flexing their fingers and practicing their tones and chords. Shouldn't pastelists also warm up by flexing their fingers and practicing their pastel marks? Like musicians testing chords, shouldn't pastelists test the color mixtures and layerings they are likely to use on the painting they are about to create? So, before creating your first oil pastel painting, we'll begin with what I call "Pastel Aerobics."

Look at your box of oil pastels and how vibrantly colorful they are in the box. Imagine the colors you will use in your painting. Now, take either a separate sheet of the same surface you will paint on, or mark off wide margins around a painting area on your actual painting surface. This will be your "Pastel-Aerobics" workout space.

Place the sticks you plan to use on your workout space. Notice that the colors look different from their appearance in the box. Some may seem brighter, or more yellow, or more blue. Add other sticks that you might not have selected before you saw the colors in context of your painting surface.

COUNTRY ROSES
Oil pastel on pastel paper,
14 × 10" (36 × 25 cm).

This painting is on brownish-gray paper. I contrasted warm and cool colors throughout to give the still life visual energy. To retain a sense of spontaneity, I was careful not to overwork the flowers.

Making Basic Marks

Now begin your workout. Take a key color and start making marks. Don't be afraid to use pressure; you need a bit more pressure with oil pastels than with traditional dry pastels. Make rows of short marks; rows of diagonal marks; rows of circles and swirls. Vary the pressure from stroke to stroke; vary the pressure within each stroke. Turn the stick on its side and practice broad, covering strokes. Use the corner of a stick, or cut a sharp edge with your razor and make fine line strokes. Continue practicing strokes until you know just how your oil pastels will behave on this particular painting surface on this particular day with this air temperature and this level of humidity.

LAYING COLOR ON COLOR

To complete your Pastel Aerobics, now try layering color on color and color mixes. Particularly experiment with crosshatching: applying close, parallel lines that crisscross, one set over the other, using layers of different-colored diagonal lines.

COLOR SWATCHES

Without worrying about drawing, start doing color swatches of focal points of the painting you will create. The swatches that follow for my peaches still life show separate color tests for the leaves, the peaches, and the wood. These tests are important, because the oil pastel sticks that I might have selected out of context take on subtly different color qualities when applied to a toned surface and also when mixed with other colors. This is a key point to keep in mind when painting with oil pastels.

When testing colors, since green is so ubiquitous in nature, knowing how to mix that color is especially important. I almost never paint with greens "out of the box"; instead, I built them up from other colors. Once I have created an optically mixed green, I might use some green from the box to develop the color further by layering a green stick over my mixed blend, or I might just use it as an accent. Sometimes I don't need a green stick at all because my mixed shade is right as is.

Try short marks, diagonals, swirls; vary their widths. Make thin lines, fat lines; vary the pressure you apply. Work with the end of the stick; work with the side of the stick to practice broad strokes. My test marks are on the Canson pastel paper that I'll use for my peaches still-life demonstration that follows. Practice your Pastel Aerobics on the kind of paper you choose for your first oil pastel still life.

As shown, experiment by layering colors to familiarize yourself with their varied effects. Keep your strokes lively by varying the tilt and pressure on the sticks. Use the broad side of a long stick to make wide shadings of color; with a shorter, broken stick make narrower marks. Use the end of a stick to make texture marks; also try various jabs and swirls. Sharpen a stick with a single-edged razor to make very narrow lines. Use two or more colors to make various side-by-side and overlapping marks, as in crosshatching, and to build optical mixes of color.

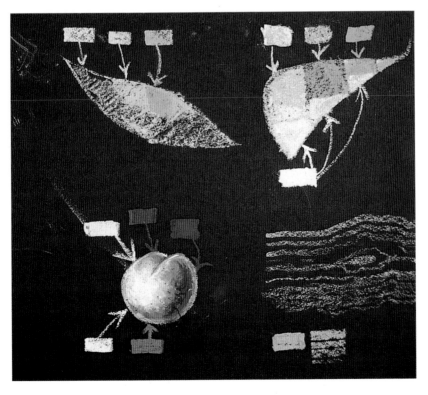

For my peaches painting, the test colors (all Holbein) are: top left leaf—sky blue, ochre/oxide yellow, Prussian blue; top right leaf—ochre, Prussian blue, emerald green, light cool gray; lower left, peach—Hansa yellow, medium rose pink, antique orange, medium Hansa yellow, light rose pink, crimson; bottom right, wood—light raw sienna.

Demonstration: Peaches Still Life

In this still-life setup of fruit spilling out of a basket, I was charmed by the way the sunlight seemed to spotlight the velvety peaches among all the old and weatherbeaten wood and basketry. That prompted me to develop the painting with emphasis on the yellows in the peaches, to make the sunny statement more boldly.

Step 1: Sketching. On the dark ground I've chosen for this painting, I make the first stroke with raw umber. Being similar to the background color, it is a conservative strategy for the initial drawing. Then I reinforce it with the more contrasting raw sienna. Keeping my sketch light enables me to make adjustments as I shape the key objects in my painting.

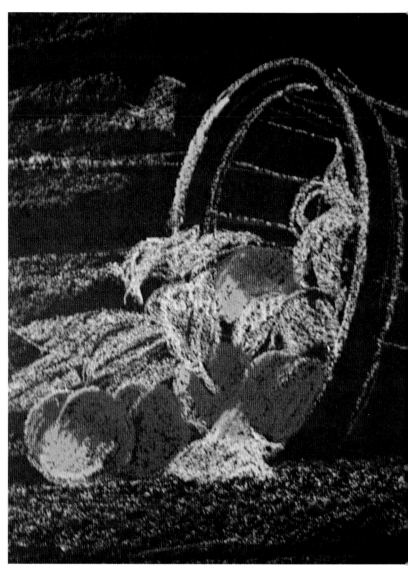

Step 2: Underpainting. I use Prussian blue to underpaint the leaves; light raw sienna for lighter areas of the peaches and sienna for the most yellow parts—also for a bit of the basket; cool rose pink for the red of the peaches, and red violet for the rosier parts. For the rustic wood, I broke an inch-long piece of cool gray and used it on its side. All of this underpainting is done quickly and freely, using medium pressure on the end of the stick, allowing much of the paper and drawing to show through. My strokes loosely follow the forms of the objects. There's no need for exactness at this point—just strokes that are lively and full of energy. If you look at the leaf area from a medium distance, it is clear that they are leaves—but up close, many of the strokes are vividly dancing around the leaf shapes. This lively underpainting style will give life and vivacity to the final painting.

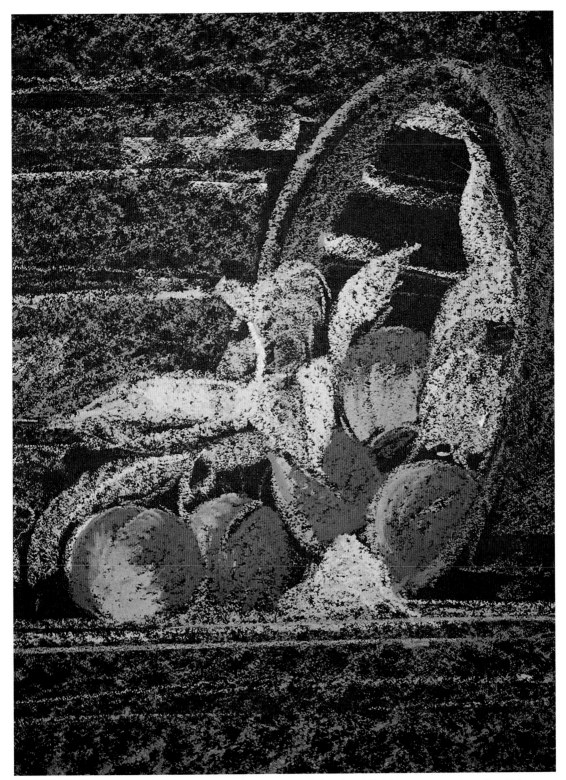

Step 3: Modeling. To bring a stronger sense of realism to the painting, I put slightly more pressure on the sticks, which reinforces the shapes and silhouettes of my picture elements. The peaches are modeled with cool red, rose pink, a touch of crimson, plus orange on the lightest parts. To create a smooth transition between colors, I overlap strokes, feathering the pastel as I work. As I start to develop green leaves, ochre is introduced over the blue, layed down loosely so as not to clog the paper. If it's clogged with too thick a layer, the pastel will not readily accept the subsequent layers still to be applied.

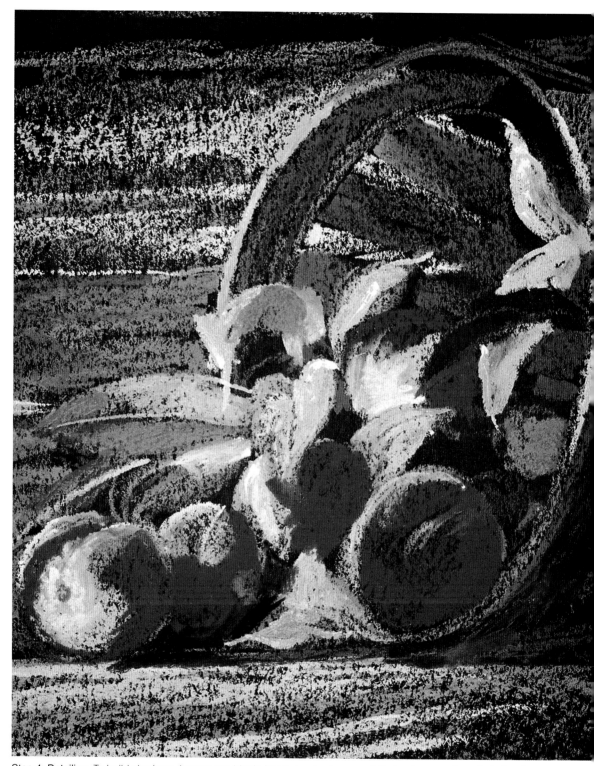

Step 4: Detailing. To build shadows, I never use black, because shadows are full of color, even though their values are dark. So I choose my deepest indigo blue, enlivened with deep purple, to indicate shadows between the peaches and basket. For further modeling of the leaves, I add a cool layer of full-strength emerald green. To emphasize the foreground leaf and give it more sheen, I apply diagonal strokes of cadmium yellow and cool gray. On the peaches, for parts in shadow, I choose a cool magenta and also use that color, but more sparingly, over some reds in the light. For accents, I apply warm Hansa yellow, changing pressure on the stick as I follow the form of the peach. The interplay of warms and cools in layers of oil pastel gives a lively, rich aura to the painting.

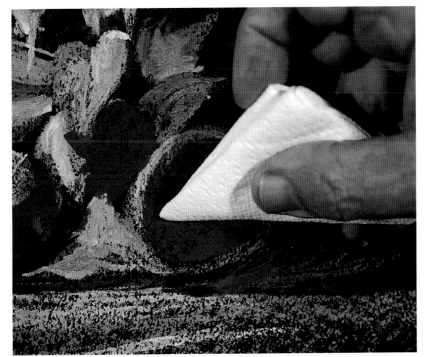

Step 5: Blending. For careful blending, I use a folded paper towel to smooth my previously applied layers of oil pastel. Another technique is to use the pastel stick itself as a blending tool. When I do so, first I put the stick on a cool surface for a few minutes to harden it slightly. Then I apply the pastel to blend some of the pastel layers beneath the mark I am making. (I keep a freezer pack handy for cooling my oil pastel sticks; more about that in our landscape chapter.)

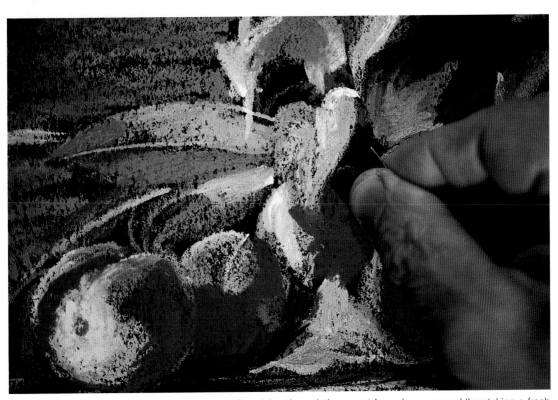

Step 6: Correcting. As I approach the last step, after giving the painting a rest for a day or so and then taking a fresh look at it, my eye immediately goes to a misplaced fleck of olive green pastel that I hadn't noticed before, so I scrape it off with a single-edged razor drawn diagonally over the mark. I avoid holding the razor straight up and never jab into the surface or it will cut through. (To correct a larger area, which should be done at an earlier stage of the painting, carefully scrape down the area that you don't want and then cover it with new pastel. The flat edge of a razor is best for that job. To remove even more pigment, if necessary, I then use an electric eraser on the scraped-down area.)

Deciding When Your Painting Is Finished

How do you know when to stop working on a painting? Your painting is finished when it does what you originally wanted it to do, when it says what you wanted it to say. That is the time to stop.

If you're not sure, it's better to stop and let the painting sit for a day or so, as I did with this peaches still life, and then carry it further later, if it needs it. If you continue painting to meet a preconceived notion of what a finished painting is, you are in danger of belaboring and ruining your work. Even though corrections are possible with oil pastel, as demonstrated here, if the painting is too over-worked, it will be difficult to fix. Remember, it's more possible to paint more than to undo an over-worked effort. So when your painting is fresh and meaningful, stop and enjoy your creation.

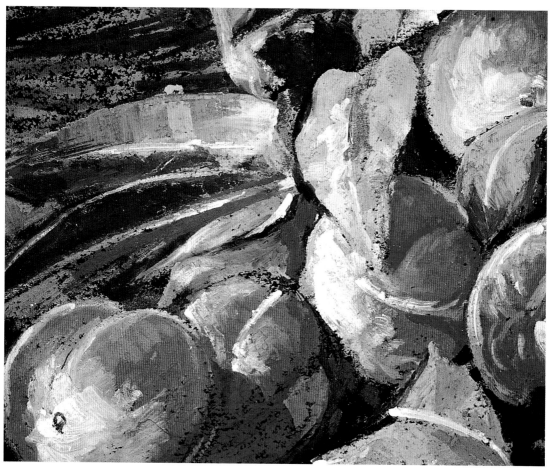

Step 7: Evaluating correction. As shown here, the glitch that I corrected with a razor was successfully repaired, and not at all apparent in the final painting.

RUSTIC STILL LIFE, PEACHES
Oil pastel on pastel paper, 10 × 8" (25 × 20 cm).

Step 8: Final touches. Using the cut edge of a yellow pastel stick, I accent leaf veins and add some highlights with light cool gray and light Hansa yellow.

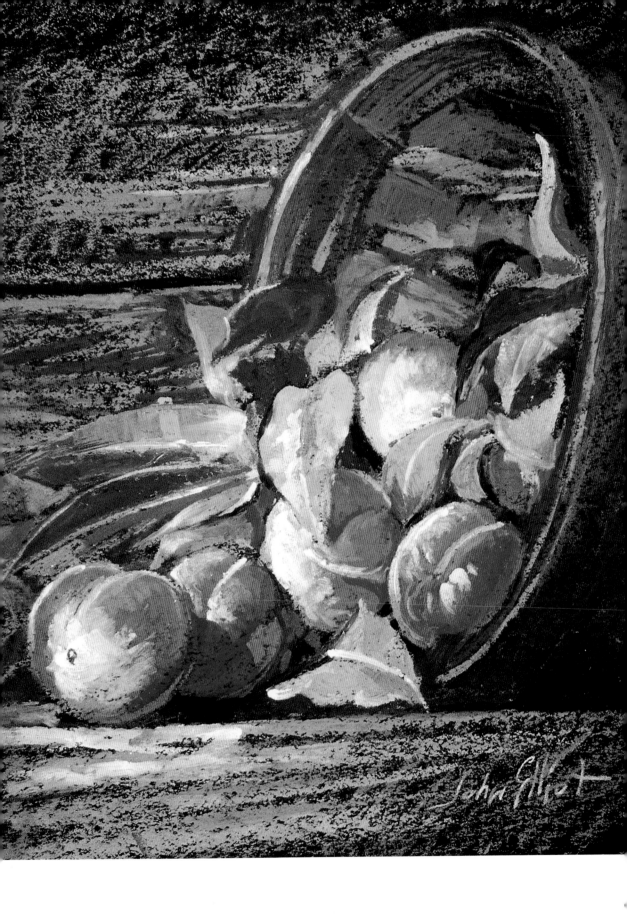

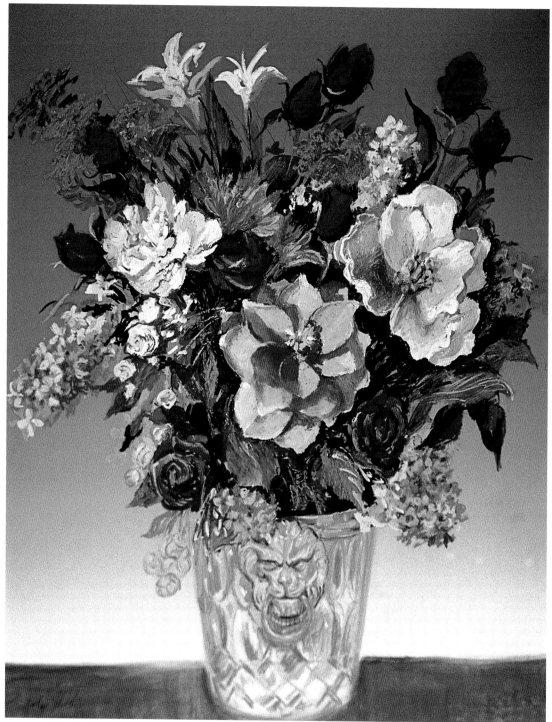

(ABOVE) SPRING BOUQUET III
Oil pastel on color-gradated paper, 25 × 19¹/₂" (64 × 50 cm).

Pantone color-gradated paper lends a dramatic background effect to this still life. For a sense of depth, I painted the closer flowers in more detail, whereas the ones more in the background are expressed with broader strokes.

(OPPOSITE) WINTER CHRYSANTHEMUMS
Oil pastel on pastel paper, 23 × 19" (59 × 49 cm).

In this painting, I varied the amount of oil pastel applied to the surface to bring focus and visual interest to the work. I expressed the wood table, vase, and background very economically; much of the charcoal-gray paper is free of any oil pastel. The flowers, on the other hand, are painted with strong, freely applied strokes. I did not blend these strokes but kept their strength and energy in full view.

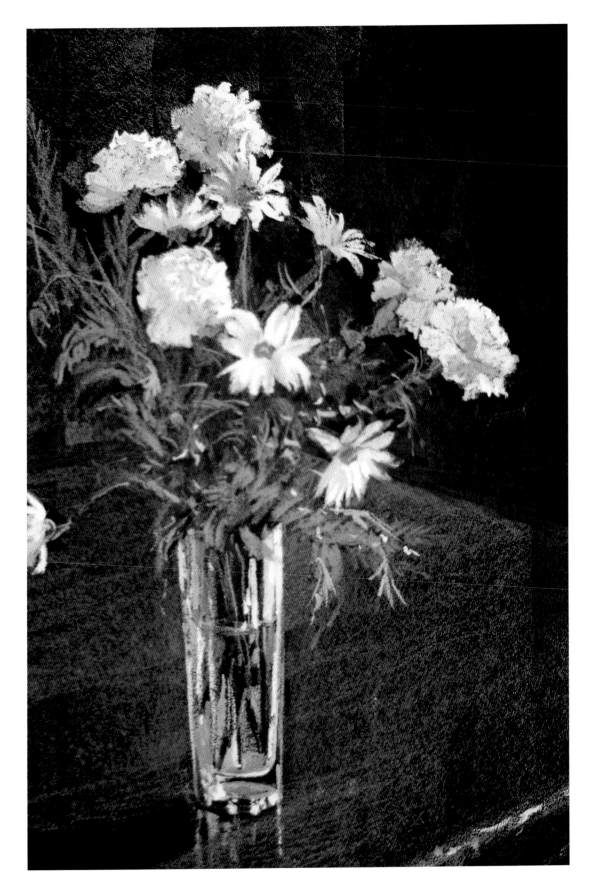

Landscape

At the start of my landscape workshops, I often hear these two issues raised: "I have trouble expressing the different textures in a landscape" and "Sometimes I get so tired lugging equipment to a painting spot, that by the time I get there, I'm almost too tired to paint." Fortunately, with oil pastel as your medium, you will never have to contend with either of those issues.

Where textural effects are concerned, oil pastel is fabulous for painting landscapes, because the medium can easily produce all the textural nuances found in a complex outdoor scene. You can paint rough rocks and tree bark, shimmering water, weathered clapboards, smooth building exteriors, and all the leafy, grassy, flowery elements of a landscape—using the techniques you will learn in this chapter.

As for portability of materials, for painting *en plein air,* oil pastel has no equal. A compact set of oil pastels, a suitable painting surface and support, a single-edged razor, and paper towels are all you'll absolutely need. (Some oil pastelists work seated, and don't even take an easel along.) You won't need to carry liquids or deal with wait time for your painting to dry. You won't need brushes, driers, stretched canvas protectors, and so forth. You won't need to fear smudging your work as you carry it back home from a painting site.

To prepare you for many such happy experiences, this chapter will cover:

- Assembling your basic materials kit for location work
- Scraping techniques
- Scumbling
- Masking
- Stenciling
- Using location references for large-size studio work
- Putting it all together: step-by-step landscape demonstration

GLIMPSE OF VERMONT
Oil pastel on pastel paper,
14 × 11" (36 × 28 cm).

I used the coarse tooth of the surface peeking through the pigments to suggest leaves on the trees. To make the grasses convincing, I limited my oil pastel to groups of strokes in the general pattern of its windswept growth.

Basic Materials for Location Work

Once you have collected a large assortment of colors and brands, as most pastelists do, you will need to preselect a smaller, more portable set of oil pastels for location work. Sometimes I cut my oil pastel sticks into smaller sizes so I can fit more colors into a compact travel box. Some sets of oil pastels come in wooden boxes that have handles. You can also purchase pastel boxes in various sizes fitted with handles, and fill them with your own assortments of colors.

SELECTING COLORS TO TAKE ALONG

When you select your assortment of oil pastels for location painting, if you already know the site and colors you will need, start with those hues. For example, autumnal colors in fall; lots of blues for a waterscape. But because the vibrancy of pastel painting depends on contrasting underlayers and unexpected accent colors, choose a set of energizing colors, intense brights, to go with your basic hues. You should add warm and cool grays for harmonizing the many colors of the landscape. Or to emphasize important darks in your painting, include indigo blue, burnt umber, Van Dyke brown; to accent light areas, include a lightest yellow, lightest blue-gray, lightest raw sienna; and always include black and white for your palette.

Finally, just to be safe, add one of every important hue you've missed, for a total of about twenty-four sticks for location work. Important hues would include: three reds—true red, magenta, strong rose pink; four browns—strong red-brown, deep red-brown, warm brown (burnt umber), cool dark brown (sepia); two greens—deep bluish green, bright true green; four blues—intense ultramarine, medium cerulean, medium cobalt, light cobalt ; three yellows—ochre, light lemon, strong cadmium yellow; three oranges—light yellow-orange, cadmium orange, red-orange; three grays—medium dark, medium light, very light; plus black and white.

You never know when one of those will be just what you need. Realizing that the color you want is back in the studio and not in your lap can be mighty frustrating.

After you assemble your oil pastels for location work, take care to protect them from the elements. Just as with pets and children, never leave your oil pastels in a hot car with the windows closed. To do that risks ruining expensive art materials.

Ideally, the outdoor temperature will be a balmy 65–75 degrees. But when I work in hotter weather, I carry my oil pastels in a lightweight cooler that includes a plastic freezer pack (often used in a lunch box) wrapped in paper towels to prevent the oil pastels from freezing in the cooler. If the weather is really hot and the oil pastels feel a bit soft, I place the rigid-plastic freezer pack under my pastel tray while I paint. If it's blistering hot, sometimes I even lay the sticks directly on the freezer pack. The sticks won't freeze, but the cold air around the plastic container tends to bring the sticks to a firming temperature.

SURFACES, SUPPORT, EASEL

A good support for a beginner is a pastel pad. Available in assorted colors that enhance outdoor painting, the pastel-pad backing serves as your drawing board. Canvas panels, watercolor blocks, and Ampersand's Pastelbord all offer the same self-backing advantage. Loose paper attached with metal clips to lightweight Fome-Cor is another option. I have successfully propped any of these painting surfaces against my dashboard when it's too cold to get out of the car. In temperate climes, I might work with one of these lightweight supports on my lap, seated on a rock or a public bench.

Eventually, you may want to invest in an easel. Although pros choose the wooden French easel with its built-in materials compartment tray, if your budget is limited, start with a student field easel—it's lightweight and folding—and take along a little folding tray table on which to arrange your pastels.

OTHER ESSENTIALS

Some single-edged razor blades for corrections and shaving pastel sticks should also be in your on-site kit; a roll of paper towels (and a plastic bag for discarding them); moist wipes for hands; and drinking water. Nothing destroys a good painting session in the field faster than thirst. In winter, I also take a thermos of hot beverage, which warms my hands, along with my stomach, while I work.

OPTIONAL LOCATION EQUIPMENT

If you travel on public transportation or on foot with only your key art supplies, do include a giant plastic bag or two, in case you must fashion an

emergency rain protector for your painting. But if you go by car, consider taking additional items that will allow you to paint in all sorts of weather.

In addition to the essentials already discussed, I pack the following:

A large, white (or off-white) standing beach or patio umbrella is useful. I can spear it into the ground or prop it in its stand and paint comfortably in the shade, even in the hottest sun. The ideal umbrella is, of course, waterproof—and never buy one with a pattern; the patterned shade will wreak havoc with your attempts to paint.

A folding chair is practical, especially if you prefer to paint sitting down (most easels adjust to a lower height). My favorite is an inexpensive aluminum folding camp chair, with a sturdy nylon seat and back. Strong, lightweight, and comfortable, it dries quickly.

A sketchbook enables me to capture changing light effects and colors in quick drawings used as reference for final paintings. Don't rely on photos for such reference; film is mediocre at best for that purpose. Learn to make color and lighting notes in a sketchbook, and always put a sheet of waxed paper between sketches made with oil pastel.

A camera is useful for reference—but not to record a scene overall, to copy back in the studio. That would defeat the purpose of going on location in the first place. Use photos for detail reference only. A digital camera is my favorite, but an inexpensive or disposable camera works just as well for recording details such as architectural trim, an arrangement of plants in a garden bed, and so on.

Finally, I find a large terry-cloth towel to be amazingly useful on location. I've used big old towels for anything from drying off after a sudden downpour, to a body shawl if the weather turns chilly and I'm not finished painting, to providing a makeshift resting pad if I need a few minutes off my feet when I may not have taken my folding chair along that day.

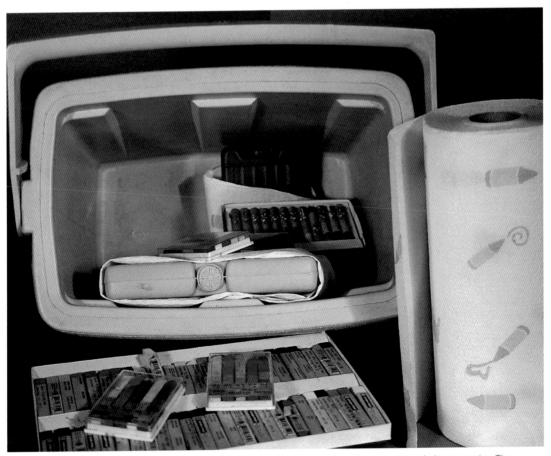

For location work in very hot weather, I place a freezer pack or two wrapped in paper towels in my cooler. The towels come in handy for blending and cleanup on location.

Creating Patterns That Suggest Landscape Elements

Continuing your Pastel-Aerobics exercises, experiment with making various line patterns that suggest landscape elements. These include line patterns that simulate rain; others that suggest sunbursts; strokes of the pastel stick that evoke barn siding; and other gestures that express different textures found in the landscape.

Because oil pastels are not brittle, you can notch them to express many of these textures quite effectively.

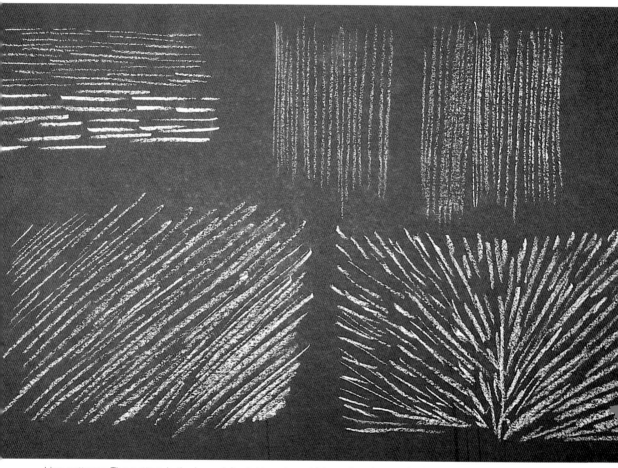

Line patterns: The pattern in the lower left might evoke a driving rain, whereas the lower right might suggest a jubilant sunrise. Remember these patterns and use them when you block in your landscape paintings.

SCRAPING TECHNIQUES

In the last chapter, you learned to make details by *applying* marks with pastel pencils and china markers. In this chapter, you will learn to make details by *removing* oil pastel that you've already applied to your painting.

The idea here is to gently scrape a small detail very cleanly with a sharp, but not too sharp, instrument. Because your scrape-outs should be bold and calligraphic—they are accents after all—you don't want a smudgy, scratched-out effect. The skill is in making a bold scraping stroke without harming the painting surface underneath, so it's important to control the pressure applied when you scrape out a detail. Grasses, small branches, and leaf veins are very well expressed with this scrape-out technique.

Notches: Oil pastels notched on the side with a razor become excellent tools for creating various textured looks. Experiment with them freely to see what new patterns you can come up with.

Clapboard: When depicting a house in the landscape, you can make clapboard effects with horizontal strokes.

Barns: For farm structures in the landscape, express barn siding with vertical strokes.

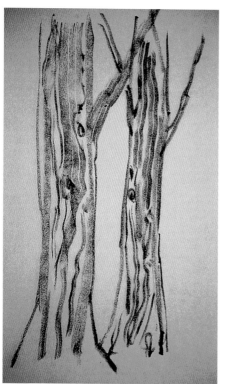

By varying the distances between the notches you cut in your oil pastel sticks, you can express weathered wood (top) and tree-bark textures (bottom).

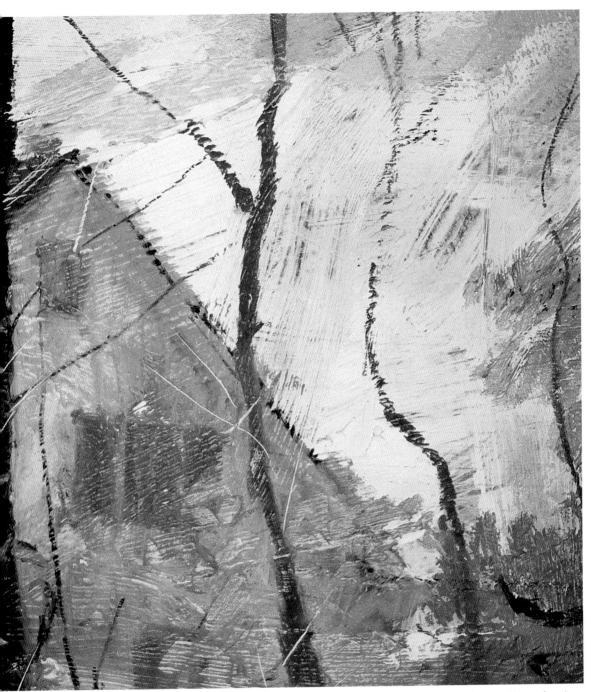

BEHIND THE ARTIST'S HOUSE (DETAIL)
Oil pastel and acrylic on illustration board, 16 × 20" (41 × 51 cm).

Here, scraping was used for details and textural effects on the roof and tree bark. Note how the fine branches are scratched out with the corner of the razor. (Be sure to use controlled pressure so you don't damage the paper.) This scratch-out is also a good technique for expressing grasses and water reeds.

SCUMBLING

In a complex outdoor scene with many different colors, at a certain point you will want to unify the colors you've applied to your surface. All colors in nature are thus unified. To get this same harmonious effect in your landscape paintings, oil pastelists use this scumbling technique.

Very lightly "scribble" with the slanted end of an oil pastel stick, or break a stick into a piece about an inch long, and use the side of the stick to overpaint the colors already applied to your painting. In effect, you are subtly and lightly blending with an oil pastel stick over previously applied pigment. No matter what colors are on the surface first, I will use a very light gray—cool or warm—for scumbling.

The scumbling technique can also create a slight veil over an initially applied color, thus creating an effect of mist, or haze, casting a moody atmosphere over a scene.

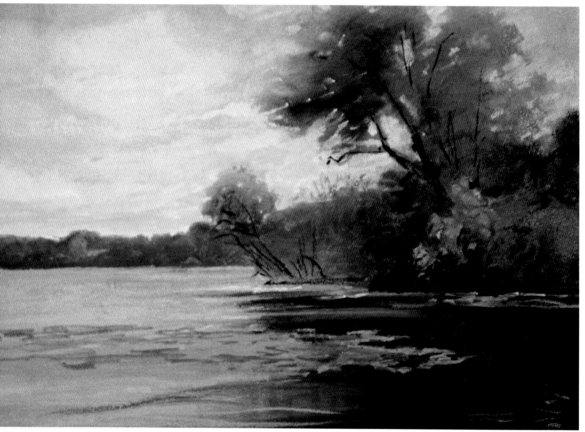

SILVER LAKE SERIES, I
Oil pastel on pastel paper,
12 × 16" (31 × 41 cm).

Don't forget to reflect sky colors in a waterscape painting. Here, I made sure that the quiet lake at sunset showed all the rosy colors of the evening sky. Because the reflected color will be less intense (the lights darker and the darks lighter) than the actual sky color, I subtly scumbled a cool gray over the water hues, then lightly blended with a razor blade and paper towel. It was important that the scumbling was not so heavy as to take away the clarity of the lake.

LAKESIDE SERIES, IV
Oil pastel on watercolor paper,
22 × 30" (56 × 76 cm).

One of the joys of oil pastel is that it offers a huge range of colors with which to express nature's ever-changing palette, such as the rich autumnal hues seen here.

MASKING WITH FRISKET

In a complex outdoor scene, you may want to keep certain parts of the paper free of pastel. For example, you can depict the moon by leaving a paper-white round shape in an indigo sky; or mask off a section to show the froth of a stream's water as the paper's white.

To mask off such an area, frisket is a handy technique. There are different forms of frisket. The version I use and recommend for oil pastelists is called Frisket Film, a self-adhesive plastic sheeting which, like masking tape, is easily removed.

Before doing any pastel work on your painting surface, apply a piece of frisket to the area you want to mask. Then cut out the appropriate shape, using very gentle pressure on an art knife or single-edged razor blade.

Remove excess frisket around the cut shape by gently lifting it off and away.

When you paint, continue your strokes over the masked-out area. This way, you will be free to make broad, sweeping, meaningful strokes with your oil pastel sticks, without interrupting your overall arm swing. You will not be inhibited by the need to lift the oil pastel stick in midstream, so to speak. Instead, you can continue to make your artful calligraphic strokes wonderfully expressed with the oil pastel medium. When your painting is completed to your satisfaction, gently lift off the frisket shapes to reveal the clean paper underneath.

Note that the watercolorist's technique of preliminary painting with liquid frisket will not work with oil pastel, since you cannot vigorously erase the material at the end of the painting session as you can with a dried watercolor. Vigorous rubbing off of dried liquid frisket would blur the edges between plain paper and the applied oil pastel. The film-frisket technique preserves clean edges.

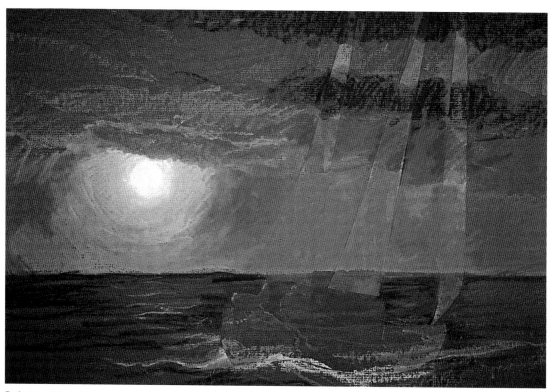

Before painting this seascape, I covered the three sail shapes with frisket. Because I wanted the sails to be the color of the painting surface, that area would remain unpainted. As I developed the sky colors, I painted right over the frisket shapes, as shown, so that the edges of the masked area would be sharply defined when the frisket is removed.

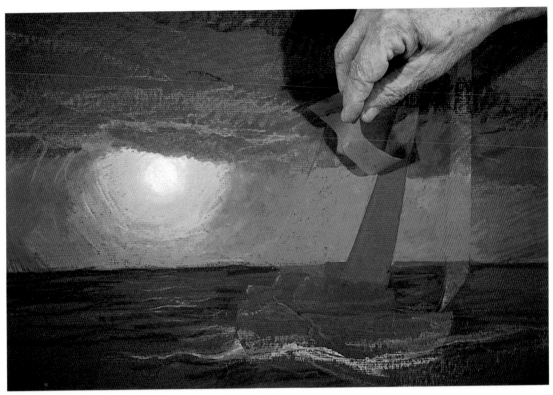

Now I lift the frisket, revealing the first sail with its clean edge.

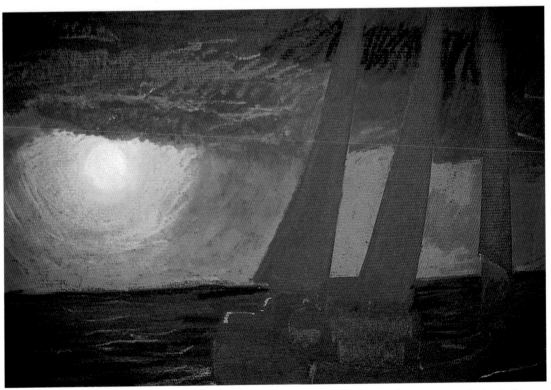

SAILING OFF KEY WEST, II
Oil pastel on museum board,
16 × 20" (41 × 51 cm).

Thanks to the frisket technique, the three sails are clean and crisp in the final painting.

Using Location Reference for Larger Studio Work

There is a mythology that pastelists are doomed to paint only on a small scale. Perhaps this idea arose from the difficulties of dealing with dust-creating dry pastels, which were the only pastels available until the mid-twentieth century. With oil pastels, however, the artist can successfully create very large paintings. The usual process is to make several small oil pastel sketches and color notes in the field. Then, back in the studio, these studies become reference material for developing large-scale works.

Since large-scale landscapes often incorporate broad sweeps of color, larger pastel sticks are good to have on hand in your studio. As noted in our "Materials" chapter, Sennelier makes a line of "giant" oil pastels that are ideal for such paintings. Another way to cover large areas is by using the sides of a standard-side stick or several sticks held together. I've even made interesting effects by holding several variants of a single hue together as a group when covering large areas. If I warm the sticks in my hand or in the sun, they tend to stick to one another naturally when I press them together, especially if their shape is square rather than cylindrical.

As for a large surface to paint on, there are several options. As a beginner to the oil pastel medium, you may not be as likely to undertake as large a painting now as you will when you're more experienced and comfortable with the medium. But let's assume that you would like to try upscaling some field sketches and studies to a painting larger than the more standard sizes of oil pastel works, which typically range up to about 24 × 36", which is a standard-size, widely available pastel paper sheet.

After making this location sketch with my creamy oil pastels, I covered it with waxed paper, which creates a barrier against possible migration of any excess oil binder to other pages in my sketchbook. Some artists take along colored pencils for location sketches, but I find they do not capture nature's intense brights and deep darks with the same integrity as oil pastels.

For your first large-scale work, one option is an archival-quality museum board, which comes in a 40-x-60" size. Alpha board or even illustration board measuring 32 × 40" can also be considered. Those sizes are not huge, but considerably larger than most pastel paper sheets. Large architectural presentation boards are another possibility, one size being 40 × 60".

When I want to create even larger works, instead of the previous choices, I buy pastel paper in rolls. One such roll is made by Canson Mi-Teintes; it's 59 inches wide and 11 yards long, and is offered in many colors. To mount the rolled paper, I purchase a sheet of 1/8" or 1/4" luan plywood in a 4-x-8' standard size at my local lumberyard. For paintings smaller than the hugh 4-x-8' size, the plywood can be cut down. For painters not equipped with saws and workshop skills, the lumberyard may do the job.

Then I seal the luan's surfaces with acrylic gesso, and use archival tape to wrap and secure the pastel paper around the edges of the luan before I paint. When the painting is finished, I frame the paper-covered luan as one piece in the frame, so I never need to remove the paper and risk tearing the already finished oil pastel painting. When I want extra cushioning of the painting surface, I tape several layers of pastel paper onto the luan. I remove the under-layers before framing. Needless to say, I need a studio assistant or friend to help when I am handling and retaping such large expanses of paper.

Finally, if I decide to use canvas instead of paper, I tape it to luan in the same way or I mount the canvas on giant stretchers as if I were going to do an oil painting.

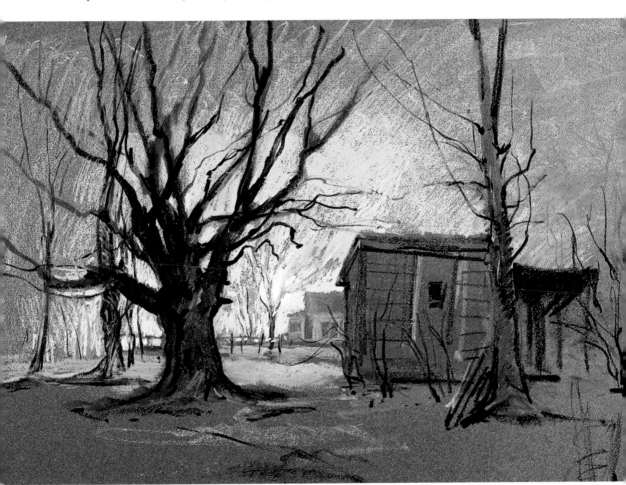

WINTER SUN AT SHARON, CONNECTICUT
Oil pastel on pastel paper,
25 × 19 1/2" (64 × 49 cm).

A location sketch like this can serve as inspiration for a larger, more fully developed painting. For this scene, working it up to a larger scale might call for detailing both the foreground and background while maintaining that brilliant burst of light as the focal point.

Demonstration: Farm Landscape

In this painting, I will work through many of the techniques available to the oil pastelist when doing landscapes on location.

I was sketching in a farmland area of north-western New Jersey, when suddenly, a summer storm approached and produced dramatic skies and lighting effects on a hayfield. This was a scene I resolved to paint. Once I assured myself that the thunderstorm wasn't imminent—but opened my large white umbrella, just in case—I proceeded to set up my materials.

As the painting evolved from rough sketch to finished work, I exercised the artist's prerogative not just to render a scene as is, but to move mountains, hills, animals, or architecture to make a work of art with added depth and meaning by introducing creative changes.

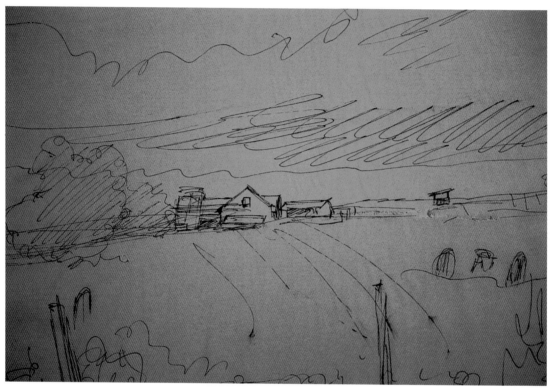

Step 1: Sketching. I used pen and ink very lightly to capture the moment in my initial sketch on paper. Then I noticed some horses in an adjoining field and decided they would be a perfect added touch for drama—horses quietly and calmly munching hay, totally oblivious to the impending storm, so I placed them very roughly just to the right of the diagonal path leading to the barn. As you'll soon see, the position of the horses and other elements shown here would be changed later as the painting developed. For my painting surface, a piece of hardboard with a warm brown tone provided the basic tonality of the dusty soil of my farm scene.

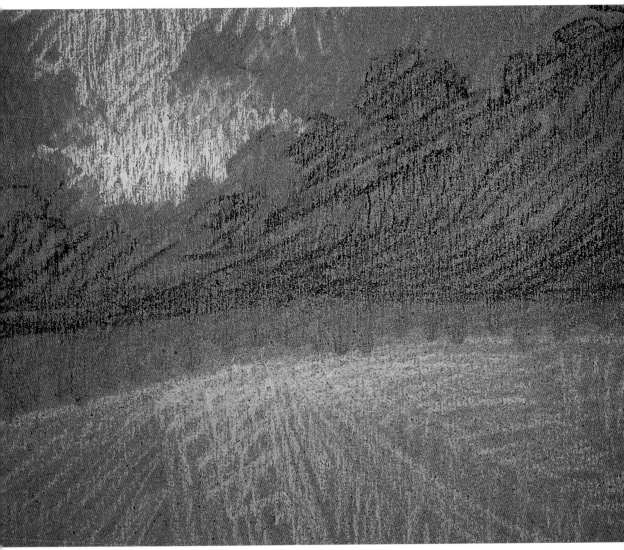

Step 2: Underpainting. I like Cray-Pas Specialist oil pastels for location work because they have paper coverings and stay cleaner in the field than unwrapped sticks. When I need to use the side of a stick, I just unwrap the paper, although it means sacrificing the cleanliness factor. The first color for my farm scene is cadmium yellow, to establish the horizon line. The contrasting sky begins with Prussian blue, applied in fast, wide strokes. Then I place cadmium yellow in diagonal strokes over the blue; where the diagonals intersect, the color becomes a greenish gray. With heliotrope purple I make sketchy vertical lines in parts of the sky. A touch of Naples yellow and then a warm pale gray go over the brightest part of the sky to suggest sunshine coming through. The edges of the storm clouds are in cobalt blue applied in circular strokes. The foreground begins with cadmium yellow, which I apply with my pastel held almost straight so the strokes are made with the blunt end of the stick. To brighten an area in front of where I expect to place the barns, I apply quick scumbles of Naples yellow.

Step 3: Establishing focal points. My palette here includes Naples yellow for the barn roof, burnt umber for the facade, burnt sienna for the left side of the building, Venetian red for the right, and sepia for the doors—all the colors blocked in with the edge of my pastel sticks. This natural variation of colors makes an oil pastel painting vibrant and life-like. For the trees, I underpaint with Hooker's green, using swirly, jabbing strokes.

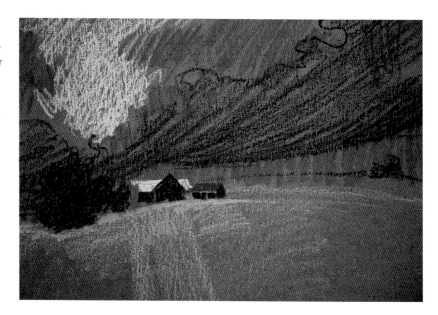

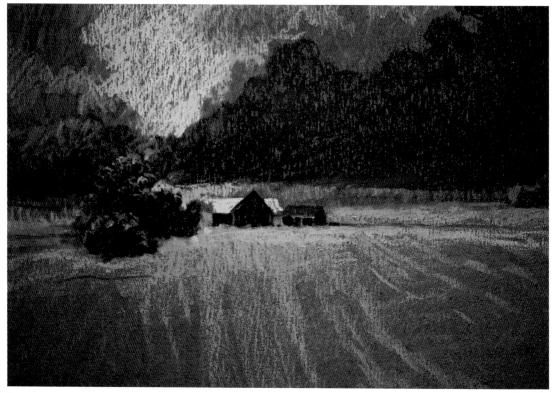

Step 4: Modeling shapes. The strokes I made earlier generally followed the contours of the elements portrayed. Now, I overpaint in contrary directions to impart a three-dimensional effect by suggesting convex or concave curves of the shapes. For example, in the middle layer of the dark storm clouds, using cobalt blue, I boldly crosshatch in the direction opposite to my earlier diagonal strokes of Prussian blue. Light sienna lends a pinkish glow behind the storm clouds and directly behind the barns near the horizon; cadmium and Naples yellow serve to pick out some leafy contours on the trees. With all of these modeling strokes I use the almost straight-on end of my oil pastel stick in lightly pressured rotating strokes to soften edges and give the scene a more humid atmospheric effect. Now I introduce some new colors: on the far-right trees, a bit of ochre; for shadows between the trees, indigo blue; for the base of the upper storm cloud and parts of the tree forms, viridian, a dark blue-green. Finally, I use iris purple for further modeling of the base of the upper storm cloud.

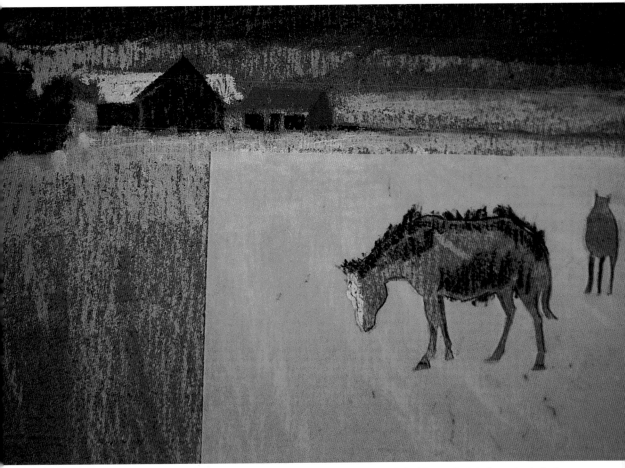

Step 5: Foreground. I see now that my painting lacks a strong foreground, so I decide to reinstate the animals that were in my initial sketch; those horses oblivious to the impending storm will make the painting more dramatic. I choose a stencil technique (see box) to add these foreground elements. Note how the color is filled in, slightly overlapping the edge of the stencil. This creates a clean outline of the finished shapes.

Stencil Technique

Stenciling allows you to apply a design accent on top of a finished painting. I often use this stencil technique when adding silhouettes of figures or animals to complete an outdoor scene. Sturdy stencil paper from an art-supply shop or even thin card stock from a stationery store will be suitable. Simply sketch the shape onto the stencil material, then cut it out with a single-edged razor or art knife. Lay the stencil on your painting. As long as you don't rub the stencil over the oil pastel while finding the right spot for it, you won't hurt the pigment underneath.

Once the stencil is positioned, paint freely over the cutout area. Manipulating temperature will assist you to make good coverage, so chill the painting surface to firm it up by laying it near your freezer pack. Meanwhile, warm the pastel stick by holding it in your hand. This results in a slightly softer oil pastel to apply easily over the slightly harder cold pastel surface.

BEFORE THE STORM
Oil pastel on hardboard,
16 × 20" (41 × 51 cm).

Step 6: Final touches.
Once the stencil is removed, I soften the edges of the horses with a stump to remove any effect of them looking "pasted" onto the painting.

FORT LAUDERDALE NIGHT

Oil pastel on alpha board,
9 × 12" (23 × 31 cm).

Painting convincing water often puts beginning artists in a quandary. Oil pastel is a great medium for expressing water because it can cover lightly, letting the tooth of the paper create a feeling of transparency. In this painting, I let the dark alpha board express the black sky reflecting in the still water. I indicate night water by very lightly swiping the side of a cool gray oil pastel stick over the reflection areas.

HOOK MOUNTAIN, HUDSON RIVER SERIES, VIII

Oil pastel on alpha board,
20 × 32" (51 × 81 cm).

Clouds in a painting can give the viewer key information about the scene's weather and season of year. The clouds' fluffiness indicates mild wind and suggests that this might be an early summer or early autumn view, when fresh, breezy days abound.

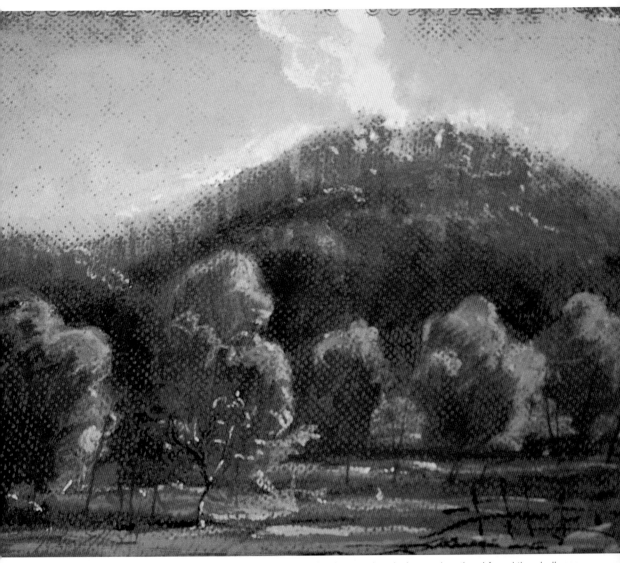

**MONUMENT MOUNTAIN,
STOCKBRIDGE,
MASSACHUSETTS**
Oil pastel on pastel paper,
8 × 10" (20 × 25 cm).

When I created this painting, in about an hour's time on location, I faced the challenge of nature's rapid changes. The mountain mist, cloud shadows, and lighting effects altered with every gust of wind. That's why I chose to paint small; it allowed me to put down the essential colors and shapes quickly. I selected a dark paper with lots of tooth so I could create textured patterns in several places: the dark base of the mountain, parts of the sky, and particularly in the foreground trees. I applied my oil pastel with a light, dragging motion to let dark background show through, which gives the impression of dappled sunlight making textures on the ground. The painterly modeling of light and dancing red blossoms on the flowering prunus tree enliven the scene. Note that I did not attempt to paint individual red blossoms, but made quick, every-which-way ribbon-like lines that evoke the essence of that special tree much more than a peppering of magenta jabs would have evoked.

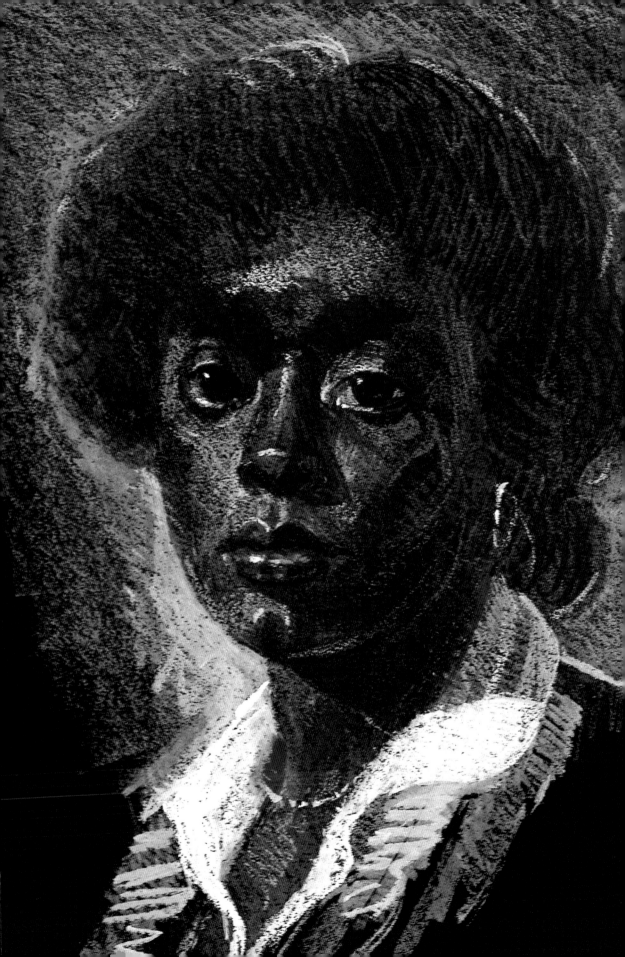

Faces and Figures

To most fledgling artists, the portrait is the greatest challenge, because the results are a yes/no proposition. There is no such thing as an in-between portrait. Either it bears an outward likeness and reveals the inner reality of the subject—or it doesn't.

While it's beyond the scope of this book to teach the particulars of capturing likeness, this chapter will show you how the special qualities of oil pastel lend themselves to creating handsome portrait and figure paintings.

For painting faces and figures, you'll utilize many of the techniques we covered earlier, but now, you'll refine your handling of the oil pastel medium by focusing on these particulars:

- Choosing a suitable ground for portraits/figures
- Modeling with a razor or eraser
- Expressing likeness and meaning
- Portraying children: step-by-step demonstration
- Props and backgrounds
- Portrait in a formal setting: step-by-step demonstration
- Time-phased portraits
- Half-length portrait: step-by-step demonstration
- Portraying the nude figure: step-by-step demonstration

We will also explore the issues of drawing skills, creating reference swatches, how to express skin tones with oil pastel, how to depict jewelry and fabrics, and various degrees of finish attainable with oil pastel. And as with still lifes and landscapes, you will soon see the remarkable versatility that oil pastel offers the artist in painting portraits and figures.

PENSIVE
Oil pastel on pastel paper,
28 × 22" (71 × 56 cm).

The charcoal-gray background and the low-key lighting were used to enhance the mood. I concentrated on the expression of the eyes in this portrait.

Portraying People

I think of your progression from still life and landscape to portraying people as being analagous to learning to play the piano. The novice musician starts by learning the keys on the piano, practicing scales, studying basic chords, then putting it together and playing a melody. Then more complex compositions follow, and the music continues to become richer and more challenging. But for this progression to be successful, the pianist must practice, practice, practice, until the mechanics of the instrument are totally internalized. Only then can the new performer break out and express an emotional, artful, musical experience that will also touch others with its artistry.

Just as the beginner pianist moves from basics to more advanced music, the beginner oil pastelist who has practiced the basics of still life and landscape is ready for the challenges of portraiture. But this aspect of the art entails an additional challenge. When you paint a portrait or figure, it's important to step back and get the essense of *you* into your artistic creation. What are your emotional reactions to the person portrayed? What do you want to communicate about your model? How will you make the viewer care about the person portrayed in your painting? Keep these considerations in mind as you approach portrait and figure painting.

When you are ready to pursue portrait commissions, your oil pastel skills with help your marketing efforts. You will be able to promise pastel portraits that are not fragile, as are dry pastels. Your oil pastel won't need a fixative, which dulls bright colors. Handling the finished portrait, before framing, is not fraught with danger. A framed work can even be glazed with Plexiglas, making it lighter and safer to ship and to hang in an earthquake region. A client in New York can commission a portrait of the family to be shipped to grandparents in Florida, and be confident that the portrait will arrive as fresh and intact as the day you completed it.

But for now, before you become a professional, take pleasure in painting portraits just for the joy of it. Eventually, the best of those paintings can become a portfolio of marketing samples for your commission work.

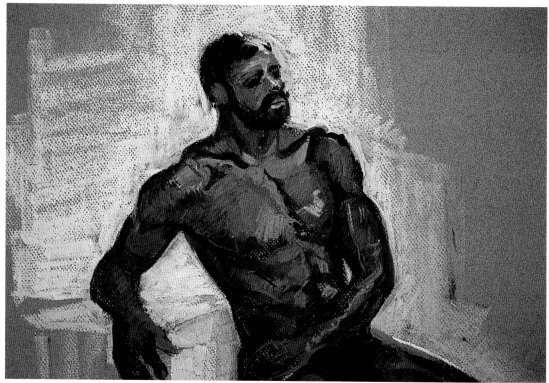

SPORTS FIGURE
Oil pastel on pastel paper,
19 × 28" (49 × 71 cm).

I selected a paper with a warm brown tone so that the color peeking through the oil pastel strokes would enhance the model's dark skin tones. For a contrasting background, I used the wide side of a stick of light, cool gray oil pastel.

Choosing a Suitable Ground

For portraying portraits or figures, you will need to consider both the tooth and the tone of the surface you work on. Although a medium-rough texture is suitable for most portrait work, you can get extra impact by selecting a finer tooth for children and young females, a coarser tooth for males and the elderly. When choosing a tone to paint on, you should consider whether your aim is contrast or harmonization. Contrast will dramatize striking visual elements, such as dark skin against an off-white background. Harmonization can be equally striking, such as painting tanned skin against a warm beige ground.

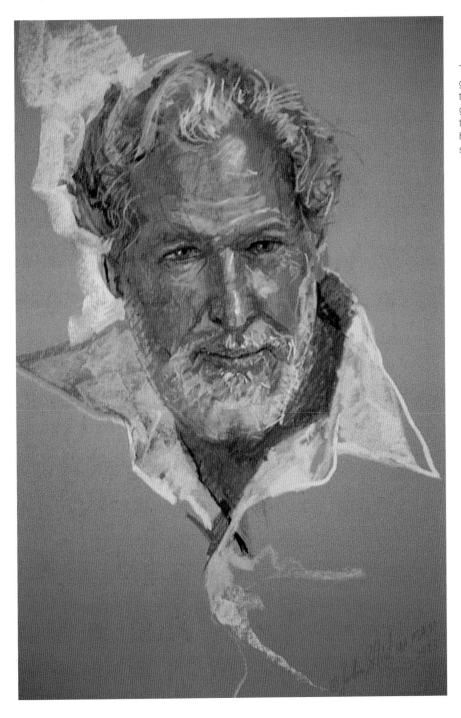

COSTA RICAN
Oil pastel on pastel
paper, 30 × 24"
(76 × 61 cm).

The buff background emphasizes the overall warm, golden tones of the sitter's skin and his buttery-beige suede shirt.

CREATING REFERENCE SWATCHES

Before settling on which painting surface you'll use, learn how your oil pastels will behave on each possible choice. Make a series of swatches that you can save and refer to in the future.

First, cut out small pieces of different painting surfaces. As much as possible, select them with the same medium-value tone, so differences in texture, not color, will be emphasized. On the back of each swatch, identify it as to brand, weight, permanence qualities, where you can purchase more of the surface, and anything else you might want to remember. Temporarily mount these swatches with masking tape on a hard surface, such as a discarded mat board.

Using any stick of oil pastel, do three types of strokes on your first swatch: a light, fine line with the cut edge of the stick; a modulated line (start light, twist, and slant the stick, applying firm pressure, and then lightly release the stick as you complete with a finishing fine line); and finally, a filled-in area made by applying the side of the stick to the surface.

As consistently as you can, repeat these strokes on each of your other swatches. You will see differences from swatch to swatch because of the different tooth levels of the surfaces you selected. If these differences are partially because you have difficulty repeating the same movements and pressures from one swatch to another, then practice the strokes elsewhere. Make this part of your Pastel-Aerobics exercises by repeating these strokes until you have the control to be consistent. This is the type of hand-control practice that is fundamental to achieving oil pastel virtuosity.

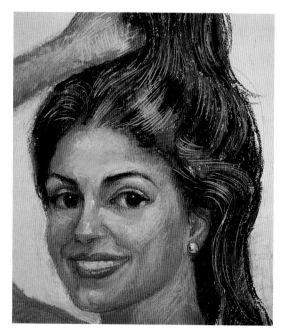

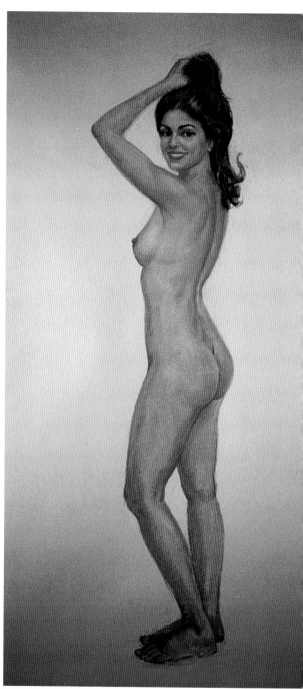

**FIGURE PORTRAIT OF
JOANNIE PENA**
Oil pastel on pastel paper,
60 × 30" (153 × 76 cm).

This model's lithe form is set off by a light background. Such an extreme contrast leads the viewer's eye to the subject's luminous skin tones and beautiful dark hair and eyes. A pale background also coordinates with and emphasizes her bright smile. For this large a painting, I used paper purchased in roll form and mounted on an acrylic-primed luan plywood panel.

Modeling with a Razor or Electric Eraser

Learning how to use tools to model facial features and figural shapes and blend their colors is a valuable skill for the oil pastelist to master. There are two such tools to consider: the single-edged razor blade and an electric eraser. We'll start with the razor.

This technique calls for first applying a liberal layer of oil pastel, usually with the side of the stick. Then, with a single-edged razor, scrape the surface of oil pastel, blending and modeling the shapes to create painterly textural effects.

Another use for the razor as a modeling tool in portraiture is to scrape the shadow areas of the subject's face. This works if you are applying oil pastel to a painting surface somewhat darker than the skin tone of your subject. These and other uses of the razor are demonstrated in the portrait of my wife that follows.

First I painted my wife's hair with plenty of dark browns, then added heavy layers of cobalt blue near her hairline, stroking with the sides of my oil pastel sticks as I followed the direction of her hair arrangement. Then, with the edge of the razor, I scraped in the opposite direction, pulling some of the blue pigment to the other areas and giving a vivid sheen to her hair.

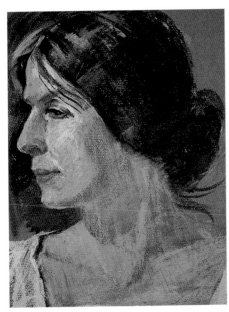

The face is modeled with lots of pinks, light sienna, and cobalt blue as an accent color. I used a razor to scrape away some of these colors under the jaw and shadow at the neck, modeling the neck cords and muscles with the razor as painting tool. Because I had selected a relatively dark painting surface, what showed through in the scraped-down section was darker, as a shadow would be.

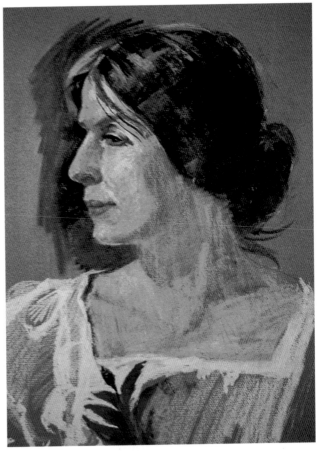

MEXICAN DRESS
Oil pastel on pastel paper, 24 × 20" (61 × 51 cm).

Marks of strong definition produced by modeling with a razor serve to communicate to the viewer that this woman possesses an inner strength.

CONTOURING

Earlier, we discussed using an electric eraser to correct small mistakes in oil pastel without damaging the painting surface. Now you will see how the electric eraser can be put to work as a painting tool with oil pastel. You can use it to achieve different effects that may be subtler than the ones produced by razor scraping. I especially employ an electric eraser when I want to clarify a contour line, as shown in the following example.

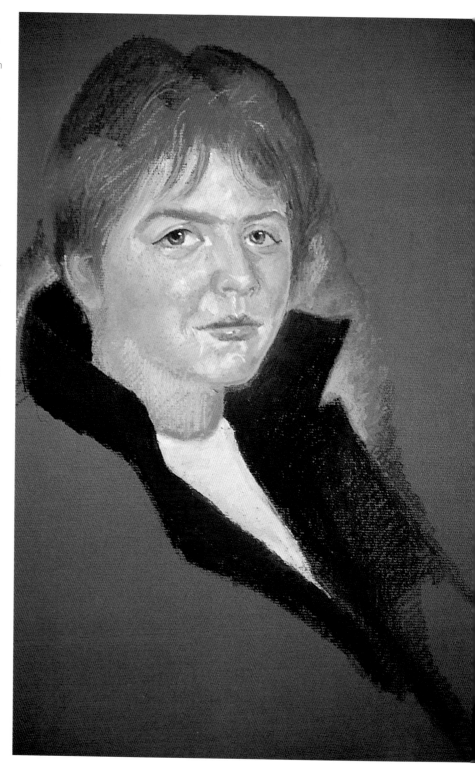

PORTRAIT OF MY SON, GIL
Oil pastel on alpha board, 30 × 24" (76 × 61 cm).

In this portrait of my son made several years ago, I gave definition to the right side of his face by using an electric eraser in a single, smooth sweep down that edge of the face and under the chin. The eraser removed much of a top level of orange along that line, revealing a layer of gray oil pastel underneath. The resulting softness helps communicate to the viewer the youthfulness of the sitter. The effect of this contouring gives a feeling of depth to the painting. Without this subtle contour line, the face might have looked pasted onto the jacket.

A Word About Drawing

You can learn the basics of painting with oil pastels to create a still life, as we did in Chapter 2—but who's to say what that peach really looked like? If you paint with confidence, the viewer will believe you, even if you were not perfectly accurate. Then, as shown in Chapter 3, landscapes are more complex, and need a higher skill level both in designing a compelling composition and in indicating nature's numerous textures and details. But still, the viewer can't possibly know exactly what those fourteen leaves looked like on the branch you studied and painted on location, or exactly how those ripples sparkled in the sunny stream in your picture. So you still have a bit of leeway on the level of your drawing skills, even in landscape painting.

Portraits, however, are a different story. Everyone *knows* what Uncle Harry or Jenny's little granddaughter looks like. So if you don't get a good likeness, the portrait is a failure no matter how masterfully you applied the colors. Your drawing skills and knowledge of anatomy are definitely on the line in portraiture.

As noted earlier, instruction in drawing the human anatomy is not within the scope of this book. Capturing likeness also entails separate study. However, if you lack confidence in those areas and do not have the opportunity for formal classroom or workshop studies, you can learn a lot from excellent, self-help instructional books. I recommend the classic *Anatomy Lessons from the Great Masters* by Robert Beverly Hale and Terence Coyle (Watson-Guptill Publications, New York); many books devoted to portrait instruction will also be found in libraries, bookstores, and art supply shops.

But even without formal studies or how-to instructionals, if you practice your drawing skills constantly, they are bound to improve. I always carry a small sketchbook and a black roller-ball pen with me. At every wait time—even standing in line at the supermarket or waiting to fill my car's gas tank—I sketch faces, figures, and objects that I see around me. When the waiting is up, I proceed with my life. I don't try to finish each sketch; the important thing is that I continually practice my hand-eye coordination.

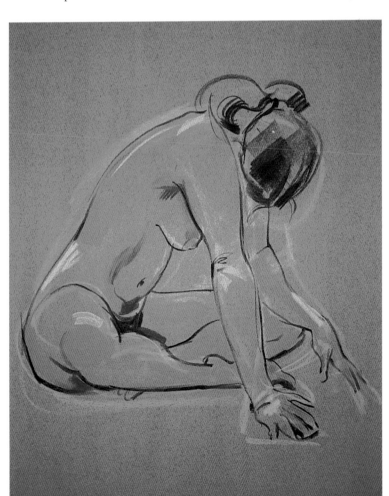

FIGURE STUDY
Oil pastel on pastel paper,
20 × 16" (51 × 41 cm).

This is one of my freely sketched figure studies. On a warm surface, I used just a few colors: Van Dyke brown for the drawing and hair; white and the lightest and medium values of English red for the accents.

Likeness and Meaning

To develop likeness in a portrait, if you work on getting the right proportions and relationships of facial features to one another and their placement on the head, resemblance will emerge. But even when a portrait looks like its subject, in this age of video and photography, the artist's portrayal must do more than just record as a camera would. You must establish a theme and give a spirit and meaning to a portrait. What aspect of this person's being do you want the viewer to focus on, to remember?

In the portrait that follows, I wanted to communicate an essential irony about my client. On the surface, he was a handsome, well-spoken, well-educated, gentle young man. But if you got to know him and gained his trust, you began to see that this apparently fortunate youth had, in fact, surmounted extremely difficult years growing up in China. The real sitter was a determined survivor whose life work was to use powerful force of character to patiently rebuild his psyche and social stature. The visual concept of my approach to this portrait would be an informal painting of an attractive young man, anchored by rock-steel eyes that compel the viewer to see the strength behind the handsome face.

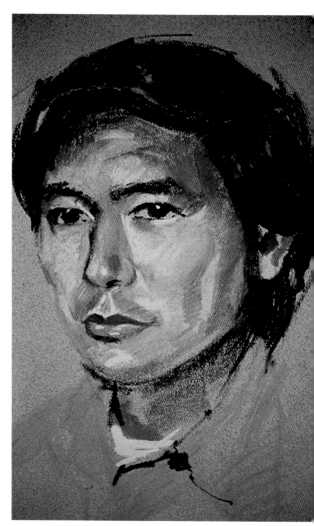

PORTRAIT OF CHUNG-YEN
Oil pastel on museum board, 20 × 16" (51 × 41 cm).

I modeled the skin tones with ochre and light raw sienna, then accented the shadows with warm gray. For the mustache, also in warm gray, I lightly sketched diagonal strokes that go opposite to the direction of the hair growth, which serves to emphasize the chiseled characteristic of this face. Taking advantage of the powerful darks that oil pastel is capable of producing, I chose the deepest, blackest brown for my point of interest: the pupils of the eyes. Even the darkest parts of the hair are not this intense a shade. After indicating the blue shirt, a final accent was a small slash of the lightest Hansa yellow over the neck color at the collar to counterbalance the strong eyes. If you cover that creamy tone with your thumb, you'll see that the painting needs it to bring out the eyes. Again, I've used the quality of oil pastels to cover opaquely, even over previously applied oil pastel, to make my visual statement.

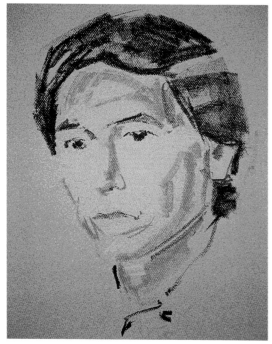

I blocked in the large masses with the sides of my oil pastel sticks, using raw umber and burnt sienna for the face and neck and Van Dyke brown for the hair. Oil pastel is well suited to this style of spontaneous work.

Portraying Children

Children are popular subjects for portraiture. For one thing, children seem to be universally attractive, so the finished painting will tend to be appealing by subject matter alone. Many children are quite open and will reveal facets of their personalities as you interact with them. That makes your job easier, since you can establish the appropriate mood for the child's portrait in less time than it often takes with adults. Even when shy, children are generally willing to talk about their favorite things, their interests, or activities. You can incorporate symbols of these personal choices into the portrait to make the painting more meaningful.

On the other hand, children can be difficult subjects because it's hard to get them to sit still and pose for you. High activity and continual change are the norm. Your visual memory will be tested to the limit as you try to remember that fleeting facial expression that you wanted to capture or perfect position of the child's legs that shifted so suddenly. To assist my memory, I do quick sketches of the child at the first sitting and also use my video camera to record reference details. Many portrait artists choose to take still photos for reference as the painting is worked on when the sitter is not present.

No matter which memory aids you use, the nature of oil pastel will also help you tremendously in capturing these restless subjects. Not only does the medium apply cleanly and with bright, clear colors for a child's portrait; oil pastel stays workable, so you can give your little model plenty of breaks to discharge pent-up energy.

With the most restlsss of all subjects, a baby, one solution is to have the mother help to hold the baby's pose. A doubly charming portrait may be the result, as seen in my *Mother and Child* painting.

MOTHER AND CHILD (DETAIL)
Oil pastel on canvas, 30 × 24" (76 × 61 cm).

To enhance the delicacy of the skin tones, I used a white background. The skin colors of both figures are raw sienna, burnt umber, Hansa yellow, and vermilion. The mother's hair is Van Dyke brown and indigo blue; the child's is yellow ochre and Hansa yellow with ultramarine blue accents. If the blond hair were on an adult, I would have added oxide of yellow and a bit of Van Dyke brown for the darker sections.

Demonstration: Child's Portrait

A little boy, engrossed in examining a sprig of gold-enrod as he sat on an abandoned farm wagon, provided a delightful scene to capture. The point of interest in this portrait—virtually any portrait—is the child's face. In some paintings, you can vary the intensities of color to bring the viewer's eye to the face. However, I wanted to limit myself to soft hues as visually communicating the springlike youth of this sitter. So instead, I varied the amount of surface coverage with oil pastel, as a more subtle way of focusing attention on the face.

Step 2: Clothing. To keep focus on the face, I made the boy's jacket deliberately less blended than his skin. Because the jacket was a complex knit pattern, I used crosshatching with wiggly, irregular strokes rather than straight ones. The jacket colors are several values of ultramarine light blue, accented with darkened gray, the collar accented with deep magenta. The sprig of gold-enrod is underpainted with raw umber, then on top, ochre for the darks and chrome and antique yellow (Holbein) for the bright florets. The boy's legs and arms are modeled with the mixed palette used for his facial skin.

Step 1: Face and hair. On museum board, I began the boy's face by applying oil pastel opaquely in olive green, light raw sienna, rose, and cobalt blue. Then I modeled the forms with the tips of my fingers, covering the tooth completely. The heat from my fingers warmed the pigment, making it easier to model the look of fine "baby" skin than would be possible with a blending stump or paper towel. For the hair, I applied burnt umber and Van Dyke brown with the sides and slanted ends of the sticks, following the direction of the hair. I blended with a folded paper towel, instead of my fingers, so the hair modeling would be less smooth than the skin. For shiny highlights in the hair, I overpainted with strokes of light cadmium yellow, olive green, and cobalt blue, applied with medium pressure to let some hair color beneath show through.

Step 3: Background. Even farther from the blended face, I used increasingly lighter applications of oil pastel, for example, olive green squiggles with the side of the stick for the background hedgerows. In the outermost part of the painting, I literally left the painting surface blank.

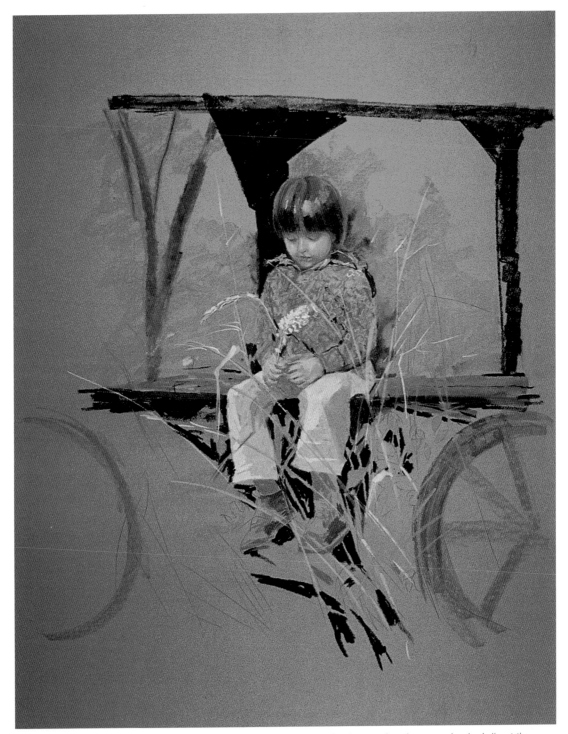

**GILBERT AT SADDLE
RIVER FARM**
Oil pastel on museum board,
40 × 30" (101 × 76 cm).

Step 4: Final touches. By keeping the background and wagon simple, I direct the viewer's eye to the child's face. And even though it's a portrait, I made the figure tiny in relation to the painting's overall size to emphasize even more the smallness of the child.

Props and Backgrounds

Accessories and settings can say a lot about the portrait sitter they accompany. But sometimes props are symbolic and so personal or esoteric, their meaning will be lost on most viewers, although their aesthetic enhancement of the portrait will be obvious to all.

PORTRAIT OF CHIEF REDBONE, RAMAPOUGH NATION
Oil pastel on pastel paper, 60 × 60" (153 × 153 cm).

For this portrait commission, the sitter brought his emblems of office to our painting sessions. Looking at the painting, an informed viewer would recognize the symbolic props and their significance to this Native American leader and his nation. But even uninformed viewers would infer that these are important symbols associated with the man portrayed.

Demonstration: Portrait in a Formal Setting

Formal portraits up through the nineteenth century were usually fully expressed paintings, wherein the subject held one of the conventional iconographic poses. Typically, the tone of those formal portraits reflected sobriety, power, and position.

Today, a so-called formal portrait is still a fully articulated painting, where background is expressed as well as the portrait subject, and a corporate portrait may still require one of the traditional "power and stature" poses. However, so-called formal portraits for personal pleasure may now display a more modern sense of life as a departure from the older, "icon" portrait formulas. Now the sitter usually poses in a more relaxed postion in an ambience that evokes his or her home lifestyle, giving the viewer added insight into the person portrayed.

Of course, a sketchy vignette, with lots of surface free of oil pastel, would not be the technique to use for detailed portraiture. To paint a formal portrait, virtuosity is required of the oil pastelist. Indeed, a successful formal portrait embodies the culmination of all the artist's skills as an oil pastel painter.

The following demonstration features a commission I did for a distinguished client. He asked me to paint a formal portrait of his wife as his gift to her in celebration of their first son's birth. The painting was to hang above the mantle in their stately home. In preliminary discussions with the couple, we resolved two issues pertaining to the visual concept. First, the format was to be horizontal. This meant that the usual poses—a full-length standing pose or three-quarter seated position—wouldn't do, as those require a vertical-format painting. The second

consideration was that the wife was very young and vivacious—not stately or formal in the least—so a modern-style informal "formal" portrait was definitely the direction to take.

I began by asking the model to sit on a handsome rosewood Victorian sofa covered in silk velvet, surrounded by antique paintings and prints—a setting especially favored by the model's husband, who is an avid antiquarian.

Step 1: Preliminary sketch. This is one of a few preliminary sketches that I tried, and it proved unsatisfactory. It suggests a demureness that was uncharacteristic of the model. Also, the pose is essentially vertical, so it would not work in the horizontal format we had agreed upon.

Step 2: Revised sketch. After we took a break to chat a bit, the model relaxed a little more and moved to the corner of the sofa—which helped to establish a horizontal format. She struck a more comfortable pose, which then settled into an even more casual one, as you will see in later stages of the painting's development.

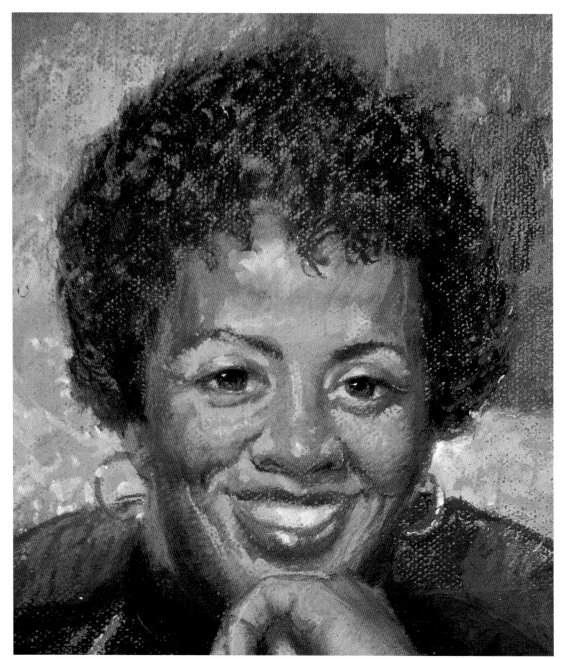

Step 3: The face. The painterly qualities of oil pastel are ideal for focusing attention on the subject's face, which should always be the most finished and articulated part of a portrait. I began by underpainting this model's skin in warm browns, adding violet and cool gray for highlights and contours. The hair is underpainted in black; over it, using firm pressure on my pastel sticks, I applied scumbly strokes of olive green and indigo blue for highlights and contours. Although scumbling is traditionally applied with light pressure,

I wanted these strokes to be emphatic, to suggest the hair's curl. The model's eyes are painted with Van Dyke brown, darkened with deep indigo, accented with red ochre for the iris, centered with black for the pupils, and white for the dots of highlight; then I used Van Dyke brown for the eyebrows. The broadly smiling lips are painted with English red and Van Dyke brown with white accent; the teeth are painted with the lightest shades of warm gray, accented with the most sparing amount of white.

Step 4: Fabrics and necklace. To keep the viewer's focus on the face, I subdued my palette for the model's dress and only lightly articulated its folds to let lots of background show through. The dress is underpainted with dark gray and olive green; subtle suggestions of pattern are added with dark blue-violet and a touch of indigo blue. Texturing on the sofa fabric is also applied economically; the colors I used there are shades of carmine, accented with the darkest value of permanent red and medium red-violet. For the necklace, first I chilled the painting in the area of the necklace by placing it over frozen ice packs. Meanwhile, I warmed a cadmium yellow oil pastel in my hand. Then, with the chilled painting back on my drawing board, I dragged the warm yellow pigment over the necklace area to depict the long gold chain.

Step 5: Ring. As with the necklace seen in the previous picture, this close look at the model's ring shows how effectively oil pastel can be used to describe jewelry, given of the medium's ability to cover with an impasto effect—a thickness of pigment. Once again, I chilled this area of the surface and then applied warmed cadmium yellow pigment for the gold of the ring; for the amethyst, I added a touch of light magenta. The model's hand is a similar blend of warm tones used on her face, but without as many highlights.

PORTRAIT OF
MRS. LOUIS NEWKIRK
Oil pastel on pastel paper,
36 × 60" (92 × 153 cm).

Step 6: Final details. One of the many details that went into completing the background included depicting the cool smoothness of the polished rosewood by using free and painterly strokes of reddish brown oil pastel to delineate the curved wood frame of the sofa. But the wall behind the sofa is painted very softly, with some deliberate vagueness. I believe in letting the viewer fill in the details. This is what gets an audience involved in a painting and ultimately makes it convincing. And, of course, by minimizing the background, as I have here, the focus is clearly on the woman portrayed, whose natural, relaxed pose and engaging smile seem to invite viewers right into the friendly setting.

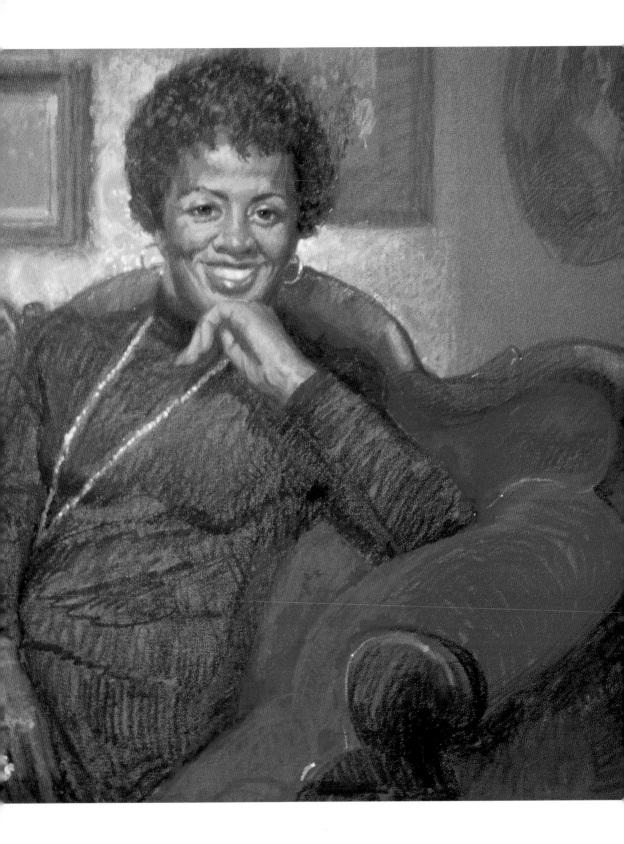

Skin Tone

Of course, an artist cannot rely on color "recipes" for developing skin tones. Within each racial group, there are broad and unlimited variations in complexion type. The age of the sitter, and sometimes the gender, also affects skin tone.

In addition, each painting has its own lighting, ambience, and color choices that are taken into consideration when depicting skin. However, I can suggest certain color combinations that have worked for me.

 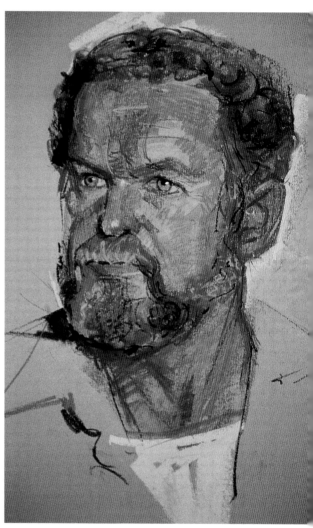

Both of these blue-eyed Caucasians have tanned skins. While I used the same colors for both models, since the older man has a deeper tan, I adjusted my palette accordingly. The optical mixture is based on two reds (Holbein Indian and English), Van Dyke brown, raw sienna, sap green, and a bit of black. The blue eyes are ultramarine, black for pupils, white for highlights. Note that white wasn't used for the older man's hair; it is based on a light, warm gray with sky-blue accents.

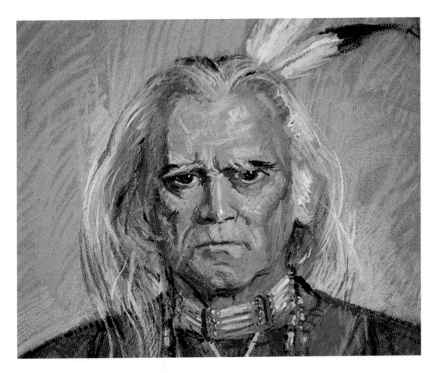

My basic palette for this Native American's skin tone began with Van Dyke brown; for modeling colors, I chose light ultramarine blue, Indian red, and yellow ochre. The model's gray hair is a blend of dark cool gray, Utlramarine blue, Hansa yellow, and white.

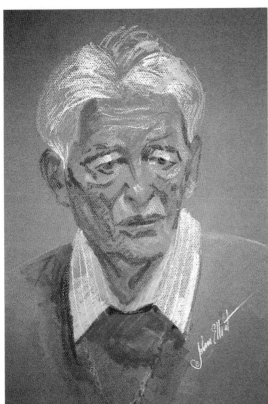

For this elderly Asian's complexion, I chose Van Dyke brown with touches of raw sienna and yellow ochre. In addition to skin tone, other visual clues that suggest this model's racial type are the contouring of his high cheekbones and the characteristic fold of his eyelids.

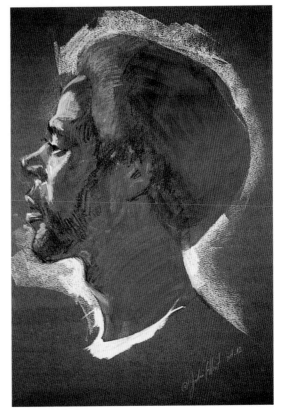

This African American's dark tone is expressed with Van Dyke brown and burnt umber, plus modeling and accents of English red, black, indigo blue, purple, sap green, and ultramarine blue. For highlights, I used Prussian blue, yellow ochre, and cool gray. The dark background complements the model's warm complexion.

Time-Phased Portraits

One of the most desirable characteristics of the oil pastel medium is its durability. That quality makes it a fabulous medium for doing time-phased portraits—painting the same subject every several years. In the long-term, the only fragility to the medium is that an oil pastel painting can "melt" if displayed in full sun, so be careful where you hang your work. Also, protect oil pastels from scratching by framing them (see page 136) or by matting and wrapping for storage in museum boxes.

If you create a series of time-phased portraits, what a wonderful wedding gift for a young couple—a gift that promises to continue giving pleasure to each grandchild in years to come. Here is a part of my future gift to my son, Gil.

GIL, AGE 8
Oil pastel on sabre tooth,
24 × 18" (61 × 46 cm).

This is an unusual portrait ,because much of the face is obscured by the book. However, the revealing title of the book and the eager eyes capture my son's absorption perfectly at that age.

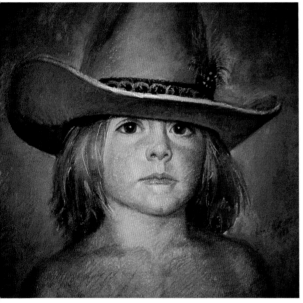

GIL, AGE 3
Oil pastel on alpha board,
26 × 26" (66 × 66 cm).

This is the portrait that started it all. I did a step-by-step demo for *American Artist* magazine in 1983, the first article about painting with oil pastels that was ever published.

(OPPOSITE) **ADOLESCENT GIL**
Oil pastel on pastel paper,
25 × 19¹/₂" (64 × 49 cm).

Here is Gil at middle-school age. Note how I expressed the forms of his face in curved strokes with oil pastel. I used the reverse side of the pastel paper so that tooth would not show through the strokes. This smoothness of the paper enhances the look of youth.

TEENAGER GIL
Oil pastel on pastel paper,
25 × 19¹/₂" (64 × 49 cm).

In the next year, I modeled the shapes more vigorously to show the increasing maturity of this young man.

COLLEGIATE GIL
Oil pastel on pastel paper,
25 × 19¹/₂" (64 × 49 cm).

A few years later, Gil had developed the harder, more definite shapes of a college-age student. The soft, adolescent curves were replaced by more angular shading with the sides of oil pastel sticks.

(OPPOSITE) **SOLDIER GIL**
Oil pastel on pastel paper,
25 × 19¹/₂" (64 × 49 cm).

Finally, after graduating from basic training in the United States Army, the searching, poetic impressions of the earlier portraits had been replaced by a soldier's commitment and determination.

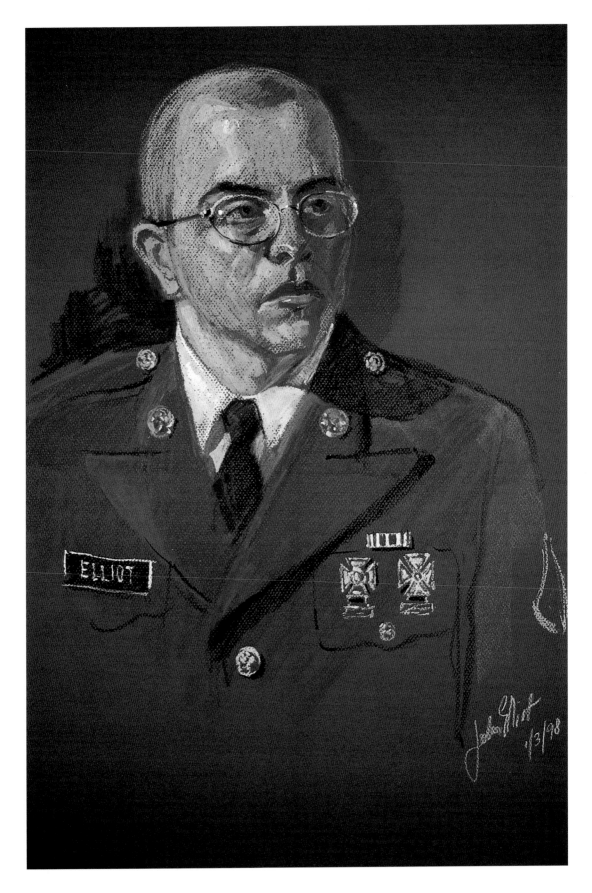

Demonstration: Half-Length Portrait

Before beginning a portrait, your first decision is how much of the model will be included in your painting: full-length, head and torso, or head only. For this portrait of my wife, Sheila, I chose a half-length format that includes her graceful arms and hands. Using an unadorned, muted background will keep the viewer's focus concentrated on the subject.

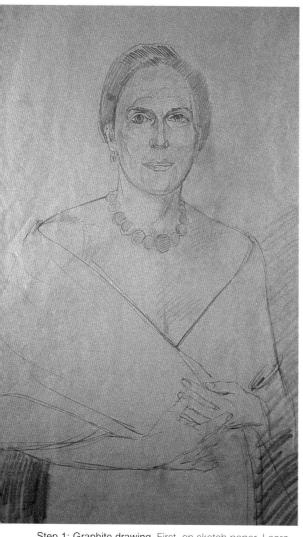

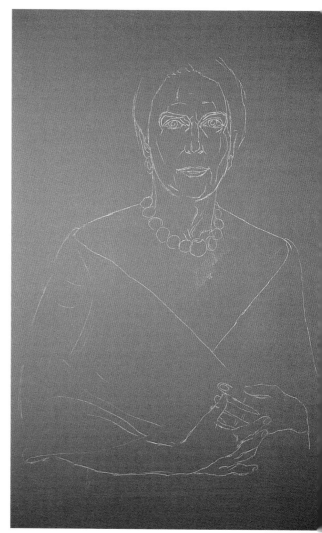

Step 1: Graphite drawing. First, on sketch paper, I carefully worked out the model's likeness. It is only through drawing—multiple sketches, sometimes—that you can truly study the subject's features and be able to translate them later into an oil pastel painting.

Step 2: Transfer sketch to painting surface. Transfer paper (similar to carbon paper, in black or white, sold at art-supply stores) is useful for tracing the essentials of a sketch onto pastel paper, as shown here. Always keep your original drawing handy in case you need to restore any of its elements during the progression of your painting.

(OPPOSITE) Step 3: Blocking shapes. I roughly block in key colors and shapes: raw sienna for the skin, carmine and permanent red for the shawl, Van Dyke brown for the hair.

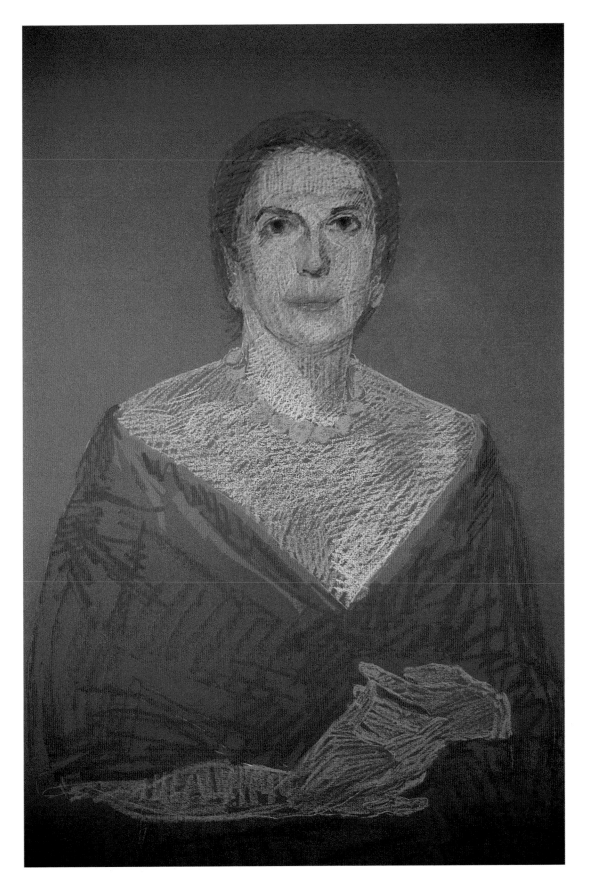

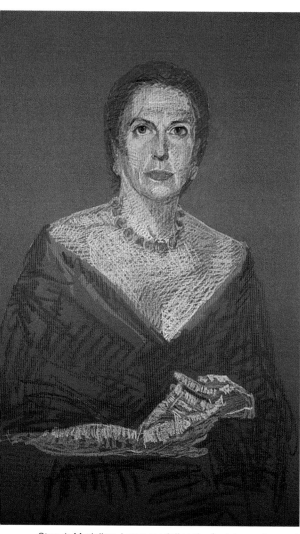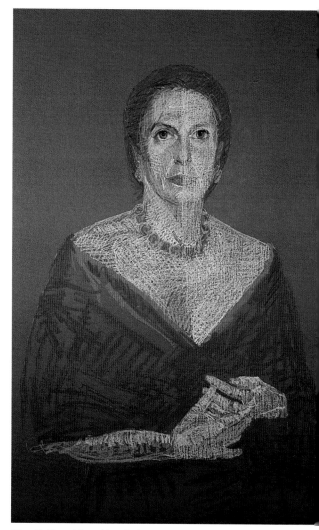

Step 4: Modeling. I start modeling the facial muscles and defining the features, using Van Dyke brown, lightened with raw sienna; for the eyebrows, Van Dyke brown and cool gray; for the lips, red ochre. For the cast shadow on the neck and small shadowed areas of the face, I lay cool grays over the raw sienna. The necklace, made of gold ornamental coins, is underpainted in light raw umber, with oxide yellow applied over it, and chrome yellow for the highlights.

Step 5: Scumbling. Now I glaze over the skin area to begin harmonizing and unifying the crosshatched tones. I use vertical lines of light raw sienna to glaze over the face, neck, and chest, as demonstrated on the right side; when the same technique is applied to the other half of the surface, the entire portrait will be unified.

(OPPOSITE) **Step 6: Scraping, blending.** Having completed the vertical blending, I use the side of a razor blade to scrape some glaze from the eyes, eyelids, and shadows around the nose and the lips, wiping the razor between each scraping. I blend the glazing with a stump to overrun some skin tone into the edge of the hair for a natural transition, to ensure that the hair won't look pasted on. I create these gentle transitions of glazing around all the features, wiping the stump between blendings. The shoulders, chest, and hands are blended delicately with a folded paper towel. To indicate the folds in the red shawl, I add touches of orange-red over the carmine and permanent red and blend it with a stump.

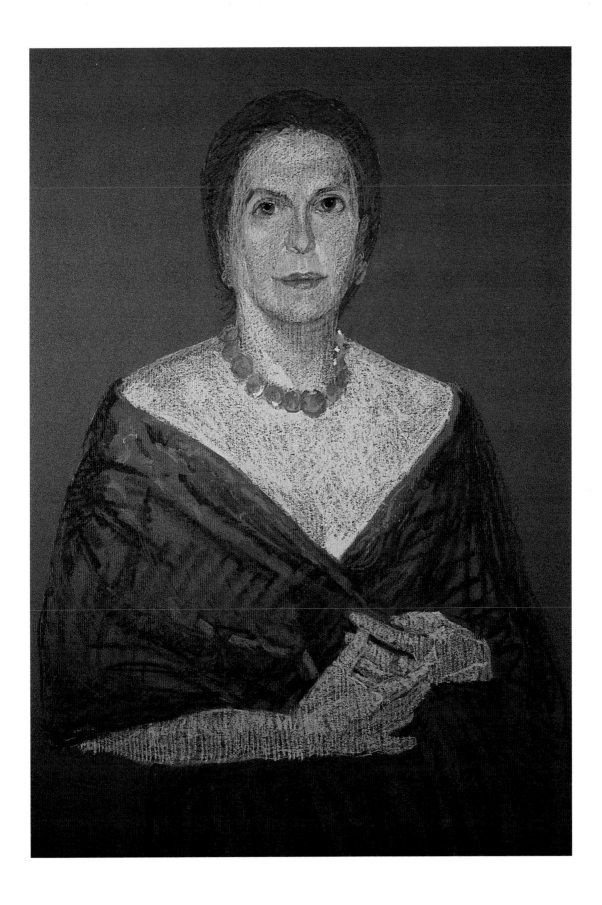

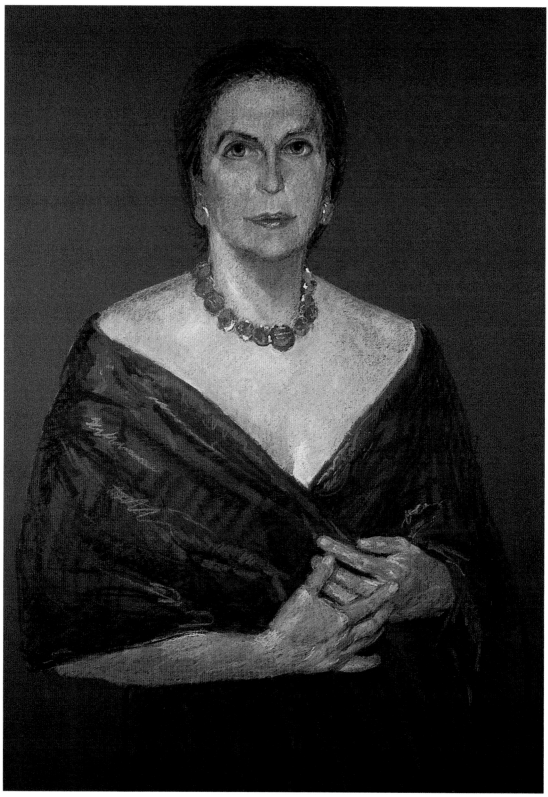

SHEILA
Oil pastel on museum board,
28 × 22" (71 × 56 cm).

Step 7: Final touches. Further blending with a stump removes all evidence of the crosshatching seen earlier, and minimizes the amount of green-paper background showing through areas of skin color. The hands are left free and painterly. I reinforce details of the necklace, and strengthen the pupils of the eyes.

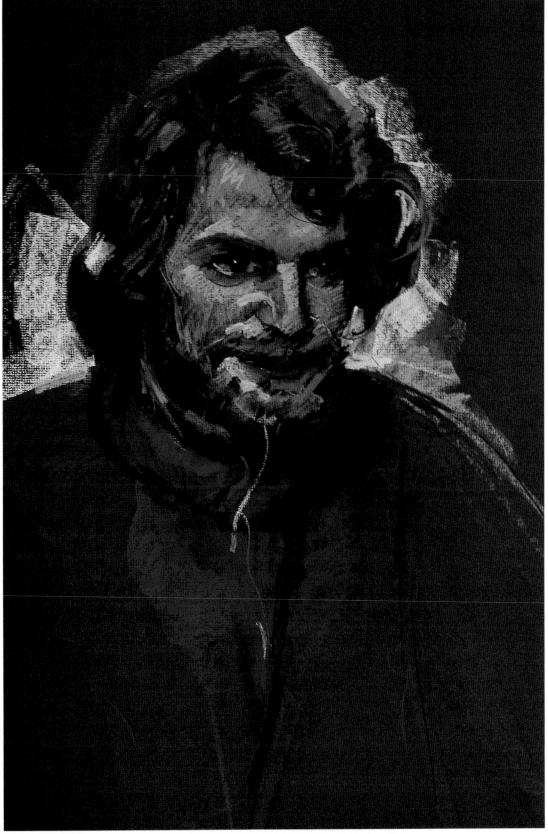

THE NEPHEW
Oil pastel on paper,
36 × 28" (92 × 71 cm).

This portrait was done as a demonstration at the Pen & Brush Club in New York. I used fast, free strokes, with no blending, to express the intense energy of the model.

Figure Studies

Typically, students arrive at a life class equipped with dusty charcoal sticks and acidic newsprint pads, as if the drawings they expect to produce will be automatic throw-aways. But in my opinion, everything an artist creates has value, even if it is to show us later how far we have advanced in our skills and artistry. So save all your work, even if you are not pleased with it at the time. And instead of working with messy charcoal and ephemeral newsprint, take your artist-quality oil pastels and archival-quality painting surfaces to each sketching session. You will be pleasantly surprised to see how many fine oil pastel figure studies you will create.

YES
Oil pastel on museum board, 28 × 20"
(71 × 51 cm).

Conversing with the model as she began to pose for me, when I asked her a question and she turned to say, "yes," her spontaneous movement, the expression on her face, and the position of her body added up to special visual material for me to turn into a charming figure portrait.

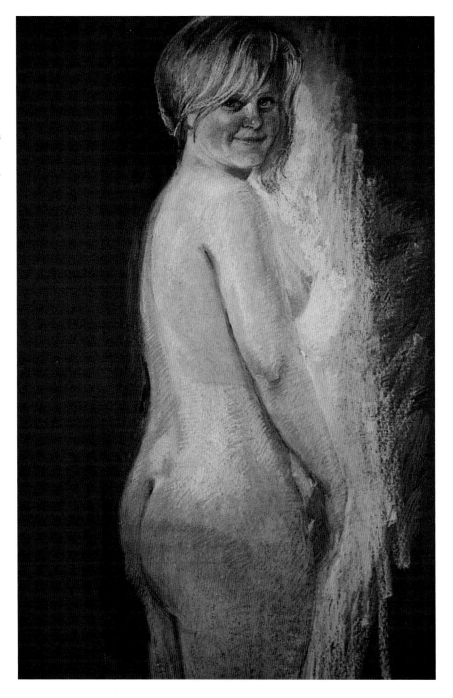

Demonstration: Female Nude

Historically, the human figure has been treated as a subject with which to express beauty and meaning in art. But recently, a new trend has emerged. Young people, who work hard to keep their bodies fit and lithe, are requesting portraits—not of their faces alone, but complete full-figure nude studies. As one of my clients put it, "When I am old and doddery, I want to be able to see and enjoy how beautiful my body was." Here is one such example.

Step 1: Preliminary sketches. These thumbnail sketches express the motif: the lovely, rhythmic motion of a graceful female body. I had this concept in mind and made these sketches before the posing session began.

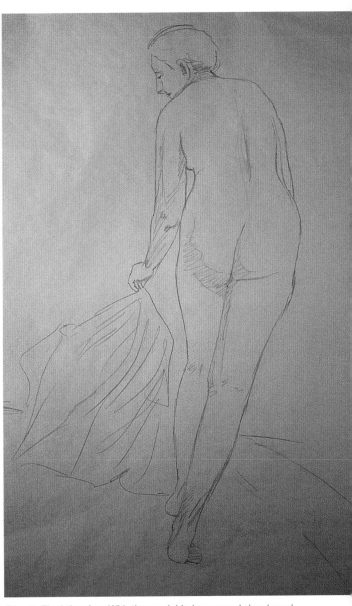

Step 2: Final drawing. With the model in her pose, I developed the concept of her gently curving body to this full-scale graphite drawing on ordinary paper.

Step 3: Transferring the drawing. I use bright daylight coming through a window to help me transfer the image to my painting surface—a delicately tinted watercolor paper that I place over my graphite drawing, then trace the outlines gently onto the pastel paper with an Indian red colored pencil. The selection of Indian red allows the drawing to become part of the artwork, to blend into the pastel skin tones to be applied; graphite pencil would not. Also, if I had chosen the transfer-paper method instead—using a kind of carbon paper placed between the sketch and the painting surface—I would have had less control over the final lines. Some might be randomly darker or lighter, and some might even have scored the paper with indentations.

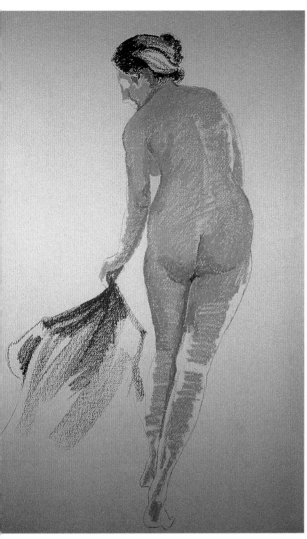
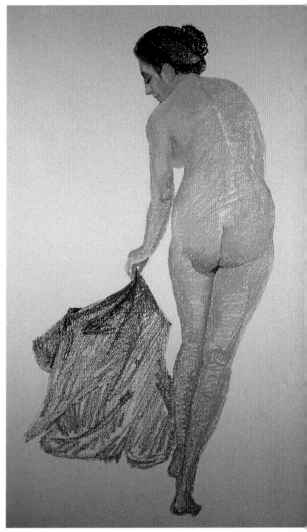

Step 4: Blocking. A cool-gray paper provides a gentle background, lighter in value than the skin tones, which will help produce subtle nuances of coloration and highlights. Consistent with this soft approach, I set up diffused lighting on the model to avoid extremes of shadows and highlights. Placing the main shapes, I use the edge of my pastel sticks—raw sienna, ochre, and Indian red. I keep the strokes very light overall, using even less pressure in the lightest areas, heavier pressure for shadows. Where I expect highlights—on the spine, for example—I let the paper show through. For the robe, I begin with rapid, spare strokes of carmine and vermilion.

Step 5: Modeling. Using the same colors as in the blocking-in stage, I model key points of the anatomy. The darker hues shape and shadow areas, as in shadings caused by the muscles. My strokes roughly follow the contour of the flesh; for example, I make wide, horizontal strokes to block in the thighs; vertical strokes with a darker shade to indicate the dark between the legs. Then I develop the dark hair and the silk robe more fully.

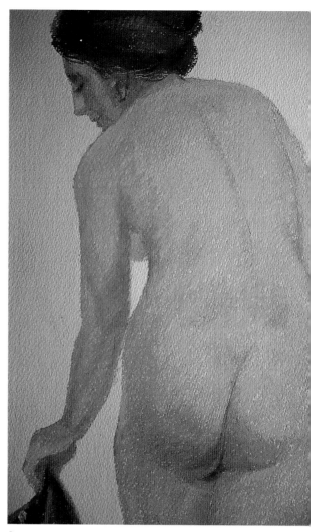

Step 6: Scraping. Up to this point, I have not done any blending. Now I use the flat edge of my single-edged razor to blend and scrape down excess pigment. I slightly overlap the boundaries of the shapes and define the cloth with more darks. The razor scraping has subtly blended the coloring of each leg and the shadow area.

Step 7: Refining. I introduce cools, including touches of greens and pinks, and refine edges by blending with a stump in a gentle, rotating motion, wiping the stump before each blending pass. The blending eliminates unnecessary textural effects in the flesh area produced by the paper's tooth.

(OPPOSITE) **SHEILA WITH RED SILK**
Oil pastel on pastel paper,
25 × 19¹/₂" (64 × 49 cm).

Step 8: Final touches. I enhance textures of the hair and cloth by softening them with stump blending, then etch out details in the hair to impart shiny highlights. Light gray accents are used to add highlights to the skin.

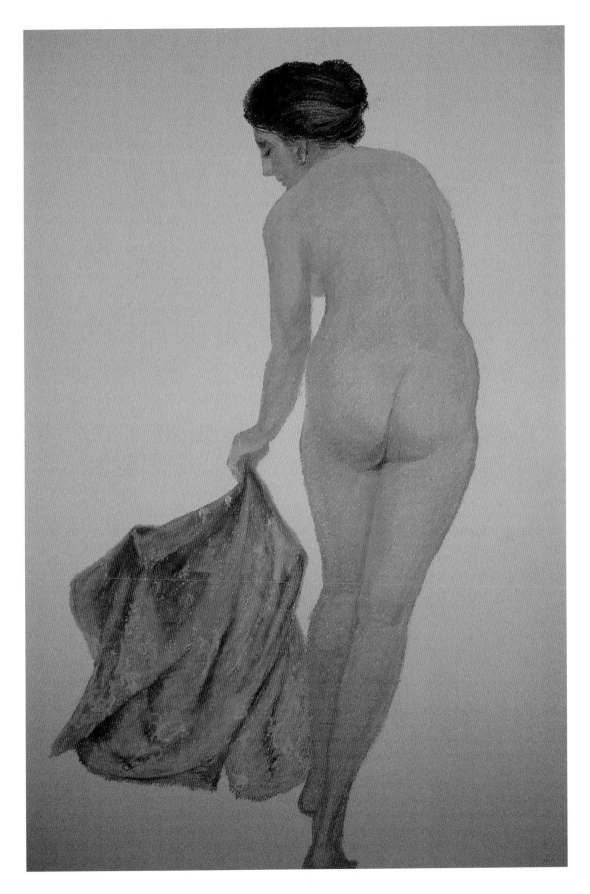

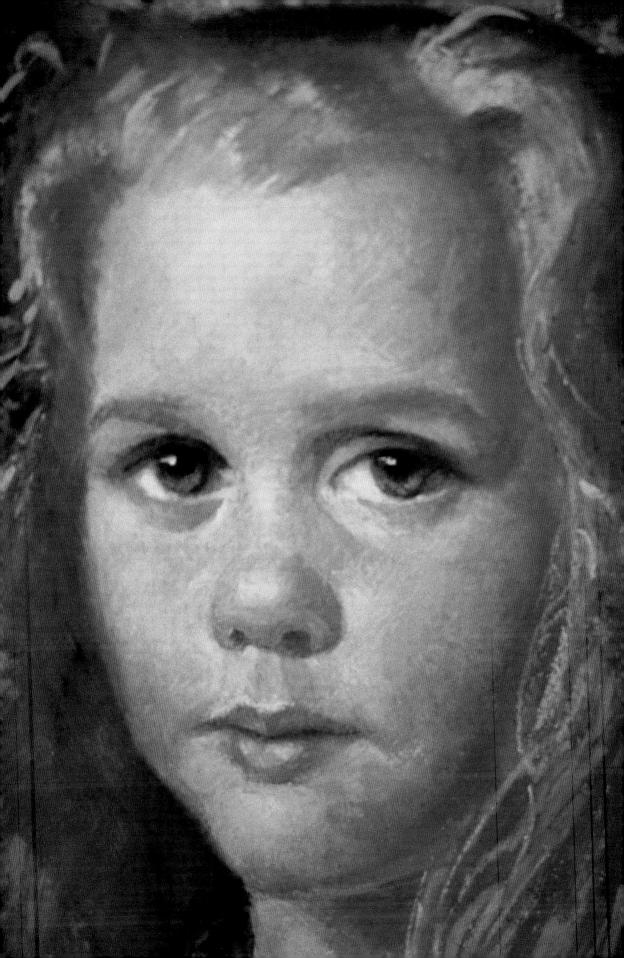

Wash Techniques Using Solvent

Is there a way to use oil pastel to make transparent wash effects? The answer is yes. With the additional tools of solvents and brushes, you can use your oil pastel sticks to create works of art that look as transparent as watercolor paintings.

There are five ways to make washes using oil pastel and solvent:

- Oil pastel mixed as a wash
- Oil pastel with brushed-on solvent
- Oil pastel lifted with brush
- Oil pastel dipped in solvent
- Oil pastel over solvent wash

These methods will enable you to make make an entire work of art using wash techniques or to intermix them in an otherwise straightforward pastel-type painting. The solvent-wash method is equally appropriate for landscapes, florals, and portraits, and is an especially useful was to work out large-scale paintings.

If you use regular oil pastels, as opposed to watersoluble, you will need a solvent such as Turpenoid, which should be used with lots of ventilation or, ideally, use it outdoors. And pick a painting surface that is sturdy enough to withstand a liquid solvent. Watersoluble pastels require an even sturdier surface, because water usually causes more rippling of the paper than a solvent. Choices for either are heavy watercolor paper, museum board, or illustration board.

You will also need sable-type watercolor brushes for making washes, as well as some brushes with coarser bristles, such as those used in oil painting. The stiffer bristles are for stippling, spattering, and rubbing actions in some of the solvent techniques. Sponges, clean rags, and a spray container are other tools to have on hand.

PRINCESS HOPE (DETAIL)
Oil pastel on museum board, 24 × 24" (61 × 61 cm).

Portraits make good subjects for the use of solvent wash and brushwork techniques as well as direct oil pastel painting in the same artwork. Skin tones, especially for young or female sitters, are well expressed with subtle brushwork.

Oil Pastel Dissolved as a Wash

Fill a bowl with some solvent. Then take an oil pastel stick and rotate it in the solvent. Grind it a bit on the bottom of the bowl to help get more pigment into the wash; the amount of pigment in the wash determines the intensity of the wash.

Mix the wash with your paintbrush to get any bits of oil pastel stuck on the bottom of the dish into the solution. This will make for a more even wash. Now apply this wash to your painting surface with a suitable brush. If you've mixed your wash well, you should have a pure wash effect.

Step 1. Rotate your oil pastel stick in solvent, grinding it at the bottom of the bowl to get a lot of pigment into the wash.

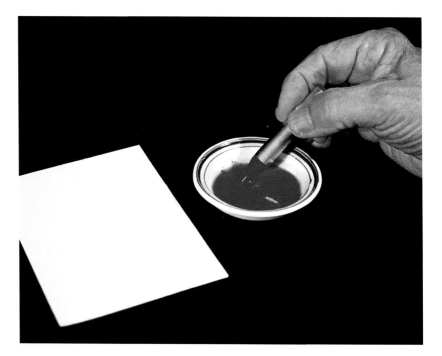

Step 2. Using a soft brush, after mixing the wash thoroughly in the bowl until no particles of oil pastel remain, you're ready to apply transparent wash effects.

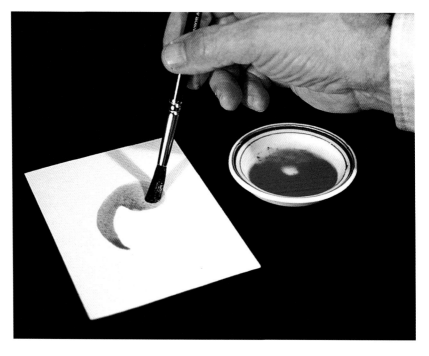

Oil Pastel with Brushed-on Solvent

In this method, first you apply the oil pastel stick directly to the painting surface. A thick application of pigment is called for as your first step.

With a solvent-loaded brush, paint over the marks you've made. Your original strokes of oil pastel will show through the wash somewhat.

To minimize those underlying marks, you can dilute the pigment further by scrubbing with a brush, sponge, or rag dipped in solvent.

However, the final effect won't be as pure a wash as the previous method, where the wash is premixed.

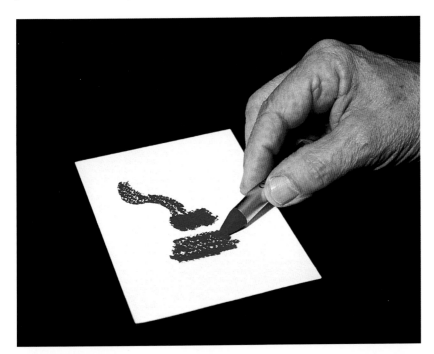

Step 1. Using an oil pastel stick, apply thick marks of pigment to your painting surface.

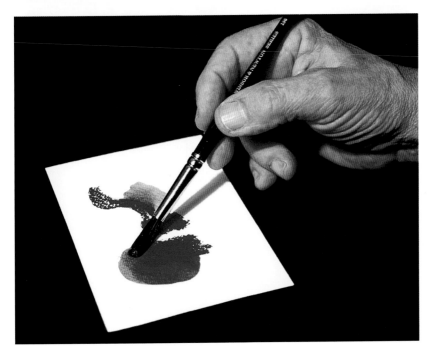

Step 2. Paint over the marks you've made, using a solvent-loaded brush to spread the pigment freely until it becomes transparent.

Oil Pastel Lifted with Brush

There are four ways to use this method. First you dip your brush into solvent, then saturate it with oil pastel pigment by drawing it over your oil pastel stick.

Now use the pigment-loaded brush to paint. By lightly tapping the brush on a paper towel before painting, to remove most of the solvent, you can even make drybrush marks.

To make spatters, you can push a solvent-loaded bristle brush hard over the end of the oil pastel. When the bristles snap down off the oil pastel stick, spatters full of pigment are produced.

Using a pastel-loaded bristle brush, you can stipple by applying the paint lightly, jabbing the ends of the bristles onto the surface.

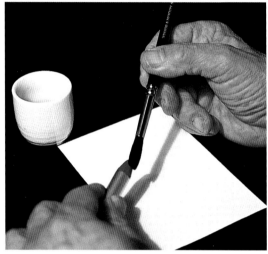

Step 1. Begin by brushing solvent on a stick of oil pastel.

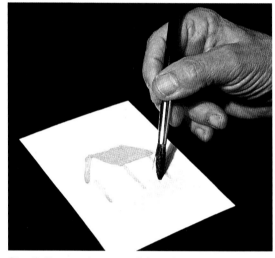

Step 2. By removing most of the solvent, you can produce drybrush marks.

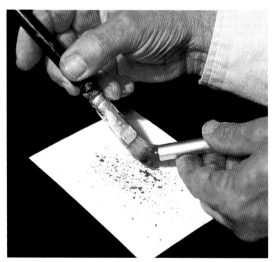

Step 3. Make spatters with the bristles of a solvent-loaded brush.

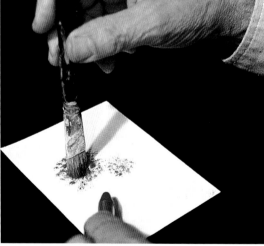

Step 4. Stipples are produced by jabbing the painting surface with the ends of a bristle brush.

Oil Pastel Dipped in Solvent

In this method, first you dip the end of your oil pastel stick into solvent and then apply it directly to the painting surface. The solvent softens the end of the stick; the solvent also flows around the mark being made, surrounding it with a colored wash.

Since the solvent dries quickly, if you make a long mark, the wash effect ends and the continuation of the stroke looks like opaque painting. You can manipulate effects by adjusting the amount of solvent used and the length you make your strokes.

Step 1. Dip the end of your oil pastel into a bowl filled with solvent.

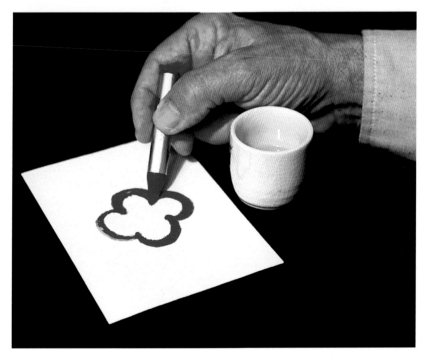

Step 2. To make a less opaque mark than this, use more solvent and work quickly, as the solvent dries very fast.

Oil Pastel Over Solvent Wash

In this method, use a sprayer, sponge, or brush to wet your painting surface.

Then apply the oil pastel stick into the wash area. The pigment flows into the solvent, creating exciting effects similar to the watercolor wet-in-wet technique.

Step 1. Here, solvent is brushed onto an area of the painting surface in preparation for applying pigment over it.

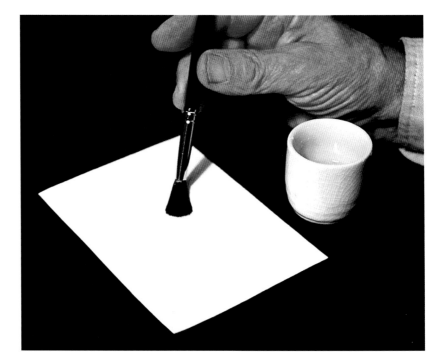

Step 2. Oil pastel is placed in the wash area while the paper is still wet. Some of the pigment diffuses, creating appealing effects.

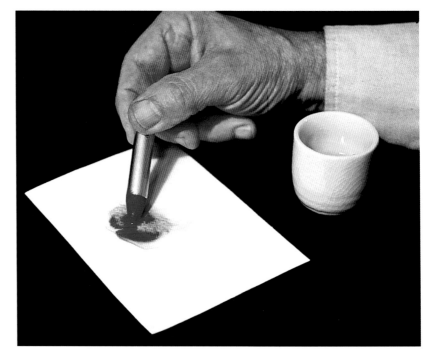

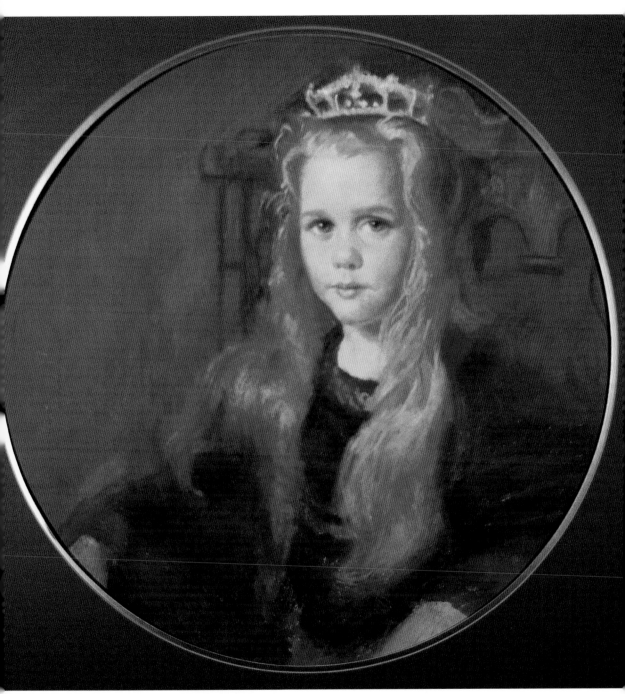

PRINCESS HOPE
Oil pastel on museum board,
24 × 24" (61 × 61 cm).

In contrast to the delicate skin smoothed with a solvent-laden brush, the crown appeared sharp and glittery when I used pure oil pastel, applied in short, stabbing strokes. I framed this square board with a circular double mat.

This detail of the painting on the opposite page shows a combination of techniques that includes using solvent on the clapboards. Employing a wash application on the structure contrasts nicely with the more opaque, direct oil pastel technique that I used to stress the vibrancy of the leaves.

Another detail of the painting on the opposite page reveals my liberal use of solvent brushwork on the tree trunk. Again, this contrast to the bright leaves nearby, painted opaquely without solvent added, lends variety and strength to the painting.

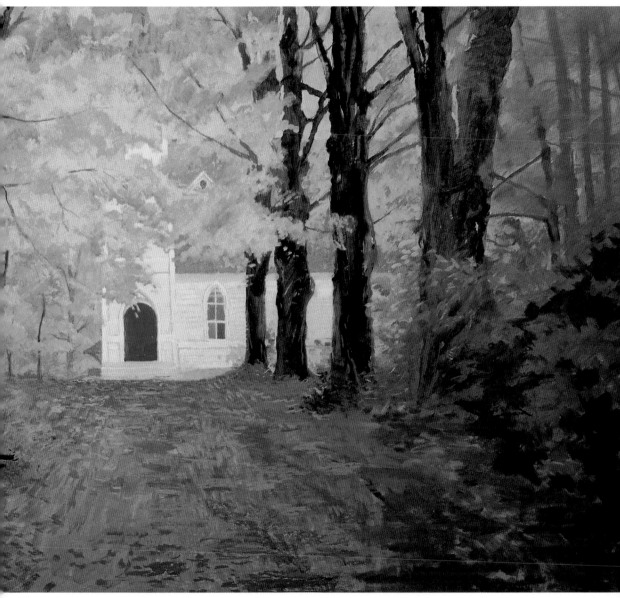

**AMERICAN ELMS, CORNWALL
BRIDGE, CONNECTICUT**
Oil pastel on architect board,
60 × 84" (153 × 213 cm).

I employed solvent wash techniques liberally for underpainting selected areas of this large picture. When painting expansive landscapes, the oil pastelist is able to cover substantial areas of a composition with a modest amount of pigment, thanks to the wash technique that stretches pigment by combining it with solvent.

CAT

Oil pastel on architect board,
72 × 96" (184 × 244 cm).

In this painting, I used only wash and brushwork techniques. Besides being economical on my oil pastel materials, the wash technique enabled me to complete this large painting in much less time than if I had used direct application of oil pastel.

This detail of the painting on pages 100–101 shows how effectively the varied textures of old wood can be expressed by using only wash and brushwork techniques.

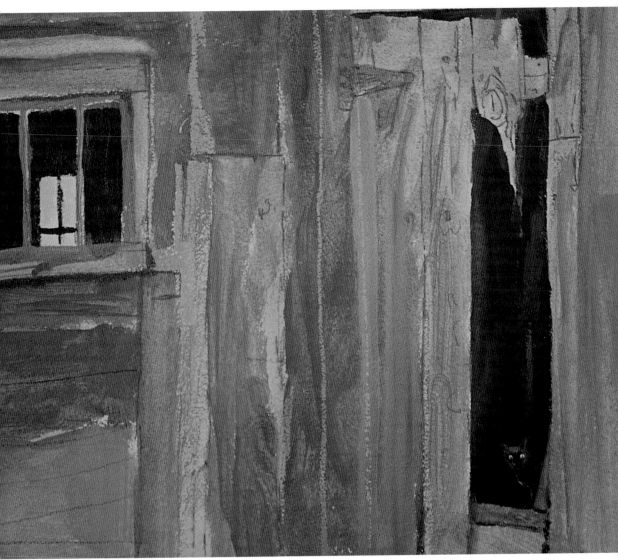

Here's another detail of *Cat*, the painting on pages 100–101. That tiny black cat in the barn's dark doorway is the only spot in the whole composition where I used direct oil pastel application—deliberately chosen to accent the subject of the painting.

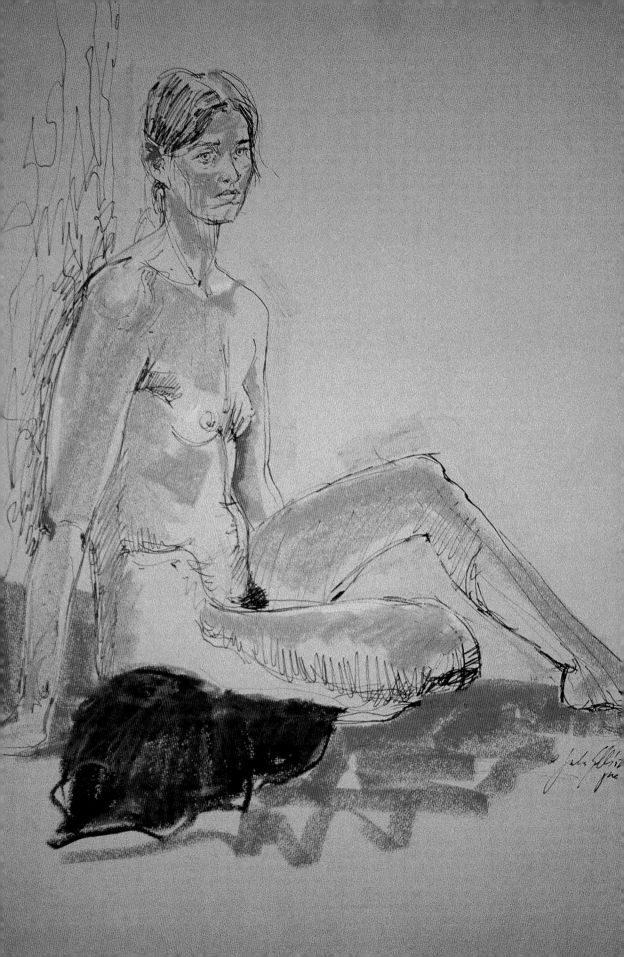

Mixed Media: Oil Pastel Plus

Dreaming about that perfect art material, the one you can use to enhance any painting, created in any medium? Think oil pastel. Versastile oil pastel is uniquely suited to be a mixed-media component. It can be applied to any surface, offering many different faces and textural effects—from soft pastel marks to transparent washes to opaque and layered impasto. And don't overlook pairing oil pastel with one or more of the other pastel forms: watersoluble oil pastel, watersoluble dry pastel, and traditional dry pastel.

Here are the imaginative mixed-media projects to be explored in this chapter:

- Combining oil pastel with watersoluble oil paint
- Oil pastel with standard oil paint
- Oil pastel with acrylic
- Oil pastel with watercolor
- Oil pastel with gouache
- Oil pastel with collage
- Demonstration: Mixed-media still life
- Demonstration: Mixed pastel bouquet

FIGURE STUDY
Oil Pastel with pen and ink on pastel
paper, 16 × 12" (41 × 31 cm).

Oil pastel combines well with pen and ink. The contrast of vibrant color tone with calligraphic ink lines makes for an intriguing picture.

Oil Pastel with Watersoluble Oil Paint

I particularly like to combine oil pastel with watersoluble oil because the two visually complement each other so well in a mixed-media painting. I also like the fact that they have both been developed to avoid the potential harm or unpleasantness of the two traditional forms they replace: dry pastel with its dust-producing problems and oil paint with its strong, odoriferous presence.

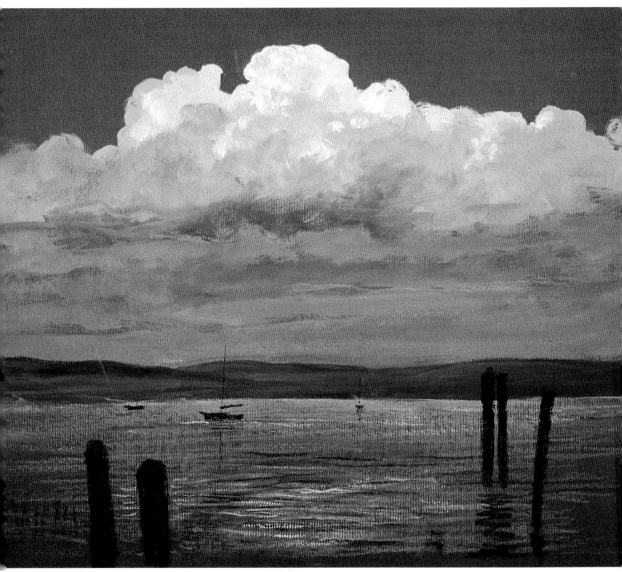

HUDSON RIVER CLOUDS SERIES, II
Oil pastel and watersoluble oil on museum board, 14 × 16" (36 × 41 cm).

The clouds are painted with oil pastel, the perfect medium to express their fluffy, opaque shapes. Smooth washes of watersoluble oil were my choice for the distant mountains and water area. The water ripples in the foreground are rendered with oil pastel over the smooth brushwork of watersoluble oil.

Oil Pastel with Oil Paint

Oil pastel is ideal as a light sketching medium in composing an oil painting. Traditionally, oil painters use charcoal or soft graphite for such preliminary drawing on canvas. But when those materials work into the oil paint applied over top, a noticeable dirtiness afflicts the first layers of oil paint, particularly if they are delicate layers, as in glazing. Oil pastel, on the other hand, works into the upper layers of oil paint cleanly, especially if you have chosen sketching colors that will blend into the color choices of the oil painting itself.

**SKETCH OF SHEILA
IN THE WOODS**
Oil paint over oil pastel on canvas,
20 × 24" (51 × 61 cm).

This is my preliminary drawing for the painting on the first page of this book, which was created in oil paint, applied over this oil pastel drawing. Since I am devoted to painting in oil pastel, this was a rare detour into oil paint, taken to demonstrate one of the many aspects of my favorite medium—oil pastel—and its usefulness to artists working in any medium.

Oil Pastel with Acrylic

When combining oil pastel with acrylic, I plan the underpainting's acrylic colors to be compatible with the subsequent oil pastel palette. I also plan my acrylic brushstrokes to create special effects with oil pastel. The results are subtle. What first appears to be an oil pastel on an ordinary surface, on closer inspection is seen to have an extra textural richness created by the mixed-media application.

BEHIND THE ARTIST'S STUDIO
Oil pastel and acrylic on illustration board,
16 × 20" (41 × 51 cm).

Oil pastel applied directly over a painting surface primed with acrylic makes for a successful pairing. Notice the added textural richness that the combination produced in this painting—for example, on the side of the house and in some of the dense foliage.

Oil Pastel with Watercolor

Sometimes the muses don't cooperate, but slyly trip your hand with the watercolor brush. You finish your watercolor session only to realize that you have an unsuccessful attempt on your hands. Rather than giving the vexing muse the satisfaction of foiling you, turn that poor watercolor into an exciting oil pastel painting. Oil pastel is excellent for salvaging dead-on-arrival watercolors. Don't toss it out; reuse that watercolor as an underpainting to an oil pastel work of art. That's what I did with the pair below; the DOA is on the left; and how it was reborn, on the right.

I am not at all happy with this watercolor. But I am happy to know that I can turn to my trusty oil pastels to come to the rescue.

SUMMER RETREAT
Oil pastel and watercolor
on watercolor paper,
18 × 12" (46 × 31 cm).

The opaque quality of oil pastel enabled me to turn this watercolor of dubious quality into an engaging scene.

Oil Pastel with Gouache

The velvety, opaque surface of dried gouache washes combines beautifully with the surface effect of oil pastel marks. Gouache is handy for covering large areas. Then you can reserve the oil pastel for the modeling and development of forms and light effects. Be careful not to apply the gouache too heavily or on a thin, fragile support. Dried gouache is relatively inflexible and brittle, and can crack if applied too thickly.

HUDSON CLOUDS SERIES, V
Oil pastel and gouache on museum board, 16 × 12" (41 × 31 cm).

Here, the horizontal swath of green describing the distant shoreline was done in gouache to emphasize the horizon subtly. Gouache was also used on the pylons. The qualities of oil pastel enhance the painting in several places—among them,the intense colors of the clouds and reflected light in the river.

Oil Pastel with Collage

Traditionally, collage is a technique that features pieces of paper or fabric pasted on a surface to make a design. Today, many collage artists glue all kinds of "found objects" to the surface, giving variety and dimensionality to the work. Oil pastel is a great addition to collage because it can be applied to any surface desired. You can make calligraphic marks and accents where you want them, thus bringing added meaning to these creations. You can even make oil pastel washes to enhance sections of a collage.

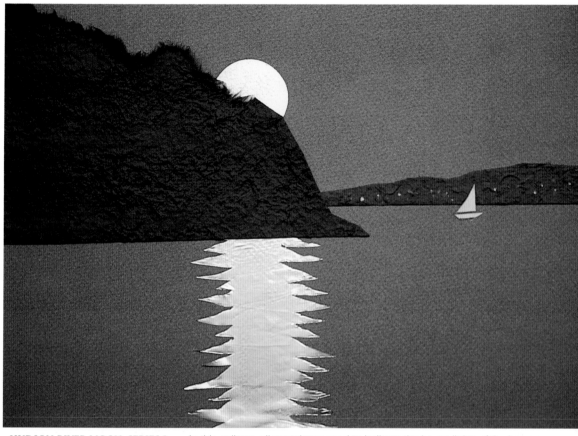

HUDSON RIVER MOON, SERIES I
Oil pastel and collage on pastel paper,
12 × 16" (31 × 41 cm).

In this collage, oil pastel was used to indicate the house lights of the homes on the distant shore. I used torn Thai Dye paper by Strathmore for the mountain shapes, and cut foil paper for the moon and its reflection, attaching those shapes with archival glue.

Demonstration:
Mixed-Media Still Life

For this harmonious piece, I will play with various media and make a visual symphony from them all. Each medium will add its unique note to the composition. I'll use primed canvas on which to paint with gouache, watercolor, watersoluble dry pastels, watersoluble oils, colored pencils, collage—and, of course, what multimedia painting would be complete without oil pastels?

Step 1: Drawing. Using oil pastel lightly on primed canvas, I sketch my casual arrangement of musical instruments and related objects.

Step 2: Underpainting touch of gouache. I plan to paint the crystal inkwell in watercolor to emphasize its transparent quality. Since I know watercolor won't adhere to this primed canvas, I paint a supporting layer of white gouache on the inkwell shape.

Step 3: Reinforcing with watersoluble oil. I use cobalt blue watersoluble oil to reinforce the drawing. The blue will later add vibrancy to the varnished edges of the brown wood instruments to be featured.

Step 4: Blocking with watersoluble oil. For the violin, the tabletop, and the two leather-bound books, I choose watersoluble oil, to help suggest the rich patina of these objects. I also block in the background to the right, and continue very sketchily to suggest the light-flooded architectural details in the background to the left.

Step 5: Blocking with oil pastel. Now I block in other objects with oil pastel: the mandolin, the sheet music in the foreground, and the music book on the stand. My aim is to have the dullness of the oil pastel surface contrast intriguingly with the somewhat glossy watersoluble oil.

Step 6: Watercolor and watersoluble dry pastel details. Now the inkwell receives transparent watercolor over its gouache underpainting, and the delicate design on the music book is painted with watersoluble dry pastel.

Step 7: Modeling with oil pastel. The bright architectural detail at the left and the body of the mandolin are now more fully modeled with oil pastel.

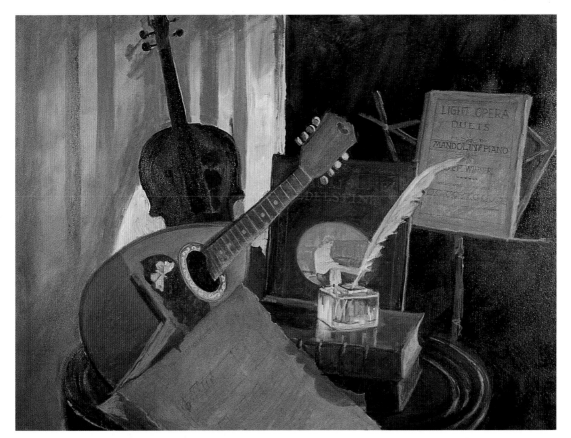

Step 8: Oil pastel and colored pencil detailing. Continuing with oil pastel, I detail the instruments. The pigment goes over the slightly tacky watersoluble oil paint with vigor and intensity; where the oil paint has dried, the oil pastel goes on a bit less intensely. With colored pencil, I sketch in the faded notes on the sheet music and titles on the book.

Step 9: More colored-pencil details. Shown in this close-up, the violin strings are ruled in with colored pencil. To indicate the mandolin strings, lines are scraped in with a sharp tool, again with a ruler used as a guide.

Step 10: Oil pastel highlights. As shown in this close-up, the butterfly, painted with shimmering Sennelier iridescent colors, truly simulates the mother-of-pearl decoration on the mandolin. As a final step, I glued an actual feather over the underpainting of the quill pen.

MAKING MUSIC WITH MULTIMEDIA
Oil pastel, gouache, watercolor, watersoluble dry
pastel, colored pencil, and collage on canvas,
30 × 40" (76 × 101 cm).

Step 11: Final touches. With final accents and highlights added,
my only decision was which medium to use for my signature; I
chose a China marker.

Oil Pastel with Other Pastel Forms

I have championed what I call the "Total Pastelist" since the early 1970s. That's about the time when artists began to find many different types of pastels on the market. With such freedom of choice, liberated artists began taking advantage of the varied effects offered by each pastel form. As a Total Pastelist, you, too, may choose the form or forms of the medium that fit your every artistic need. There are several specific reasons why it's useful to combine pastel forms.

For example, to emphasize different textures in a complex subject, combine washes with watersoluble pastel, smudgy areas made with dry pastels, and vigorous marks and jabs made with oil pastel. In a landscape, to assist in expressing depth perspective, use soft pastel in the background and more emphatic oil pastel in the foreground. To create self-fixed underlayers with compatible tooth, a dried pastel wash gives pastel pigment the right texture to grab the next layer.

Finally, you may need a certain color and find it only in one type of pastel in your supplies on hand. Especially where important accent colors are concerned that will cover only a small area in your painting, different texture would not be too apparent—but the wrong color would be very apparent, so that's another reason to be flexible and pragmatic about mixing pastel forms when it helps a painting.

Many students ask me if there are rules about what *not* to do with pastels—such as never put certain ones side by side; never put dry pastel over oil pastel; and so on. Are there rules? No. There are just different effects and possible uses for these effects.

Experiment with your own sets of pastels and see what you can do. You'll soon discover the appealing effects that can be realized by combining oil pastel with watersoluble forms of oil pastel and dry pastel with traditional dry pastel. Many of my experiments in mixing these forms are shown on the following pages.

Oil pastel (left) next to watersoluble oil pastel (right): There is no visible difference in the two patches.

Oil pastel (left) next to dry pastel (right): The coverage of the oil pastel is firm and smooth; the dry pastel is less dense and more velvety. The dry pastel doesn't appear as attached to the surface; it looks like it's just lying on it.

Oil pastel (left) next to watersoluble dry pastel (right): There is a slight difference between the two patches; the one on the left looks more attached to the painting surface and somewhat smoother and denser.

Oil pastel (bottom layer) covered with watersoluble oil pastel (top): Watersoluble oil pastel opaquely covers the regular oil pastel. There is no visible difference between the two pastel forms.

Dry pastel over oil pastel: Oil pastel is on the bottom; dry pastel covers it with difficulty, showing many gaps. The dry pastel doesn't exhibit its characteristic velvety bloom as not enough of its pigment can be laid down.

Watersoluble dry pastel over oil pastel: Watersoluble dry pastel covers the oil pastel only slightly more than regular dry pastel covered the oil pastel. The textures of the two materials seem more compatible than the regular dry pastel over oil pastel.

Oil pastel over watersoluble oil pastel: Regular oil pastel covers opaquely, though optical color mixing is evident.

Oil pastel over dry pastel: The oil pastel acted like a pickup on the dry pastel. Rather than laying on oil pastel pigment, the loose dry pastel pigment stuck to the oil pastel stick and was removed from the patch.

Oil pastel over watersoluble dry pastel: The oil pastel acted somewhat as a pickup, but not as completely as with the dry pastel. The oil pastel left little pigment on top of the watersoluble dry pastel patch.

Demonstration: Mixed Pastel Bouquet

For this demonstration, I arranged a mixed floral bouquet to be expressed with three types of pastel: dry, watersoluble dry, and oil pastel. The bouquet features roses with delicate petals, lilies with sensual curves, and leathery laurel leaves among other blossoms and greenery. I chose materials and techniques that would highlight their contrasting textures. To support the delicate luminosity of the bouquet, I selected a 300-lb Winsor & Newton watercolor paper, which has a nice tooth, but more important, will stand up to washes and manipulation.

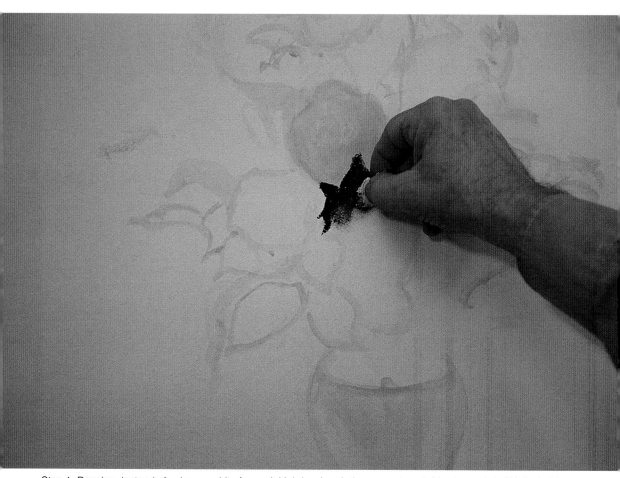

Step 1: Drawing. Instead of using graphite for my initial drawing, I chose a watersoluble dry pastel of Holbein blue. This very light wash drawing would not interfere with the translucency of the rose's initial pink wash of watersoluble dry pastel. Another advantage of this type wash is that once it dries, it stays put and actually enhances the surface tooth by grabbing hold of the upper layers of pastel. Also, while the wash was still wet, I could make corrections by dipping my brush in water, then lifting marks I wanted to remove. I use a folded paper towel to blend the start of a leaf, also done in watersoluble dry pastel.

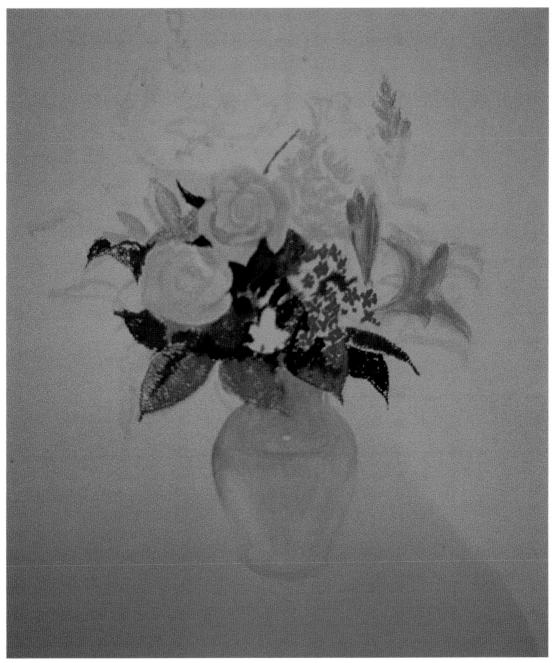

Step 2: Blocking. Following just the general shapes of the dominant flowers, I block in their base colors, underpainting some of the lilies with a golden yellow oil pastel. For the strong, leathery leaves I use oxide of olive and sap green oil pastel, then with a towel, blend the parts of their leaves that will recede into the interior of the bouquet.

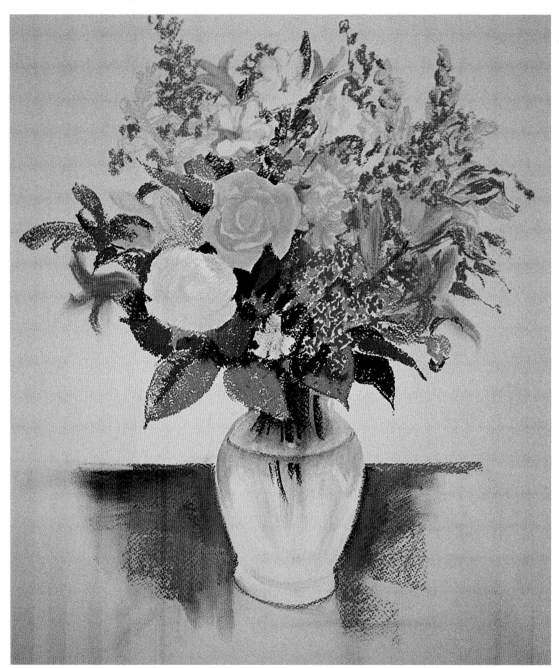

Step 3: Defining. The painting now displays an interplay between the strong effects of the oil pastel leaves and the delicate wash of the rose petals. The white rose is washed with yellow watersoluble dry pastel in only a few places, following the curves of the petals. The pink rose, underpainted with light pink, is now heightened with washes of yellow, coral, and a light raw sienna. I also use the sharpened edge of a dark blue-gray stick of oil pastel dragged lightly over the shapes for more linear definition. The leaves are in oil pastel shades of olive, sap, and

emerald greens, accented with ultramarine blue, with expressive details etched out on them. The foreground stephanotis blossoms are in magenta oil pastel, and in the upper rear of the bouquet, in a slightly darker magenta, in dry pastel. In fact, dry pastel is used for all the upper flowers and leaves. Their softer edges are consistent with their place in the background and create an impression of depth when contrasted with the more distinct shapes in the foreground. The vase is based on the same blue watersoluble pastel wash that I used for my initial sketch.

Step 4: Detailing. This detail shows the dominant lily, which is based on a wash of orange watersoluble dry pastel, with accents of oil pastel over it. Bold, calligraphic brushstrokes give the flower its sensuous curve.

Step 5: Detailing. This detail shows how jabbing staccato strokes of magenta oil pastel describe the stephanotis in the painting's foreground. This kind of stroke imparts a dimensional effect, leaving bits of oil pastel attached to the small shapes.

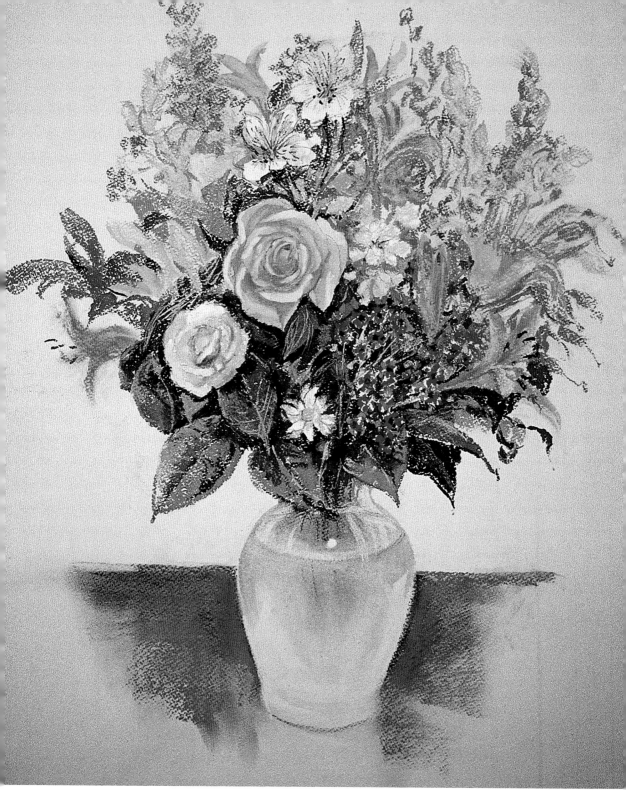

SHEILA'S BOUQUET
Oil pastel, watersoluble dry pastel,
and dry pastel on watercolor paper,
20 × 16" (51 × 41 cm).

Step 6: Final touches. To finish the vase, I applied dry pastel to describe
the curved water line, blending it with a dry bristle brush to soften the
effect. I chose dry pastel to suggest the table surface and keep it softly in
the background.

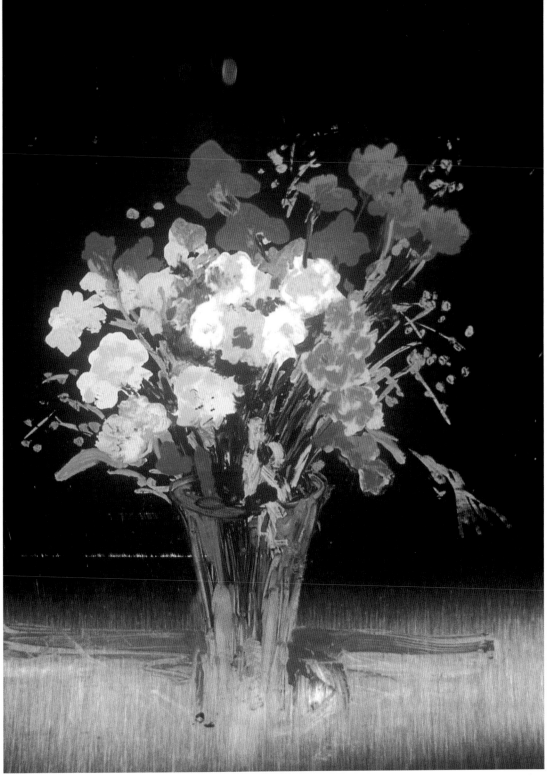

FLORAL FIREWORKS
Oil pastel on metal plate,
36 × 24" (92 × 61 cm).

While mixed media works on most surfaces, in this case, I decided to stay with oil pastel only, to express the cheerful mood of a riot of summer flowers, using a shiny metal plate as my surface. But any medium other than oil pastel would not have adhered as well to the surface. So for the flowers, I underpainted with Holbein, then applied soft Sennelier oil pastel with energetic jabbing and swirling marks. The stems, vase, and tabletop are painted more economically by dragging the firmer Holbein sticks along the metal surface. This strategy renders these elements less important than the bright flowers, which are the stars of this "fireworks" display.

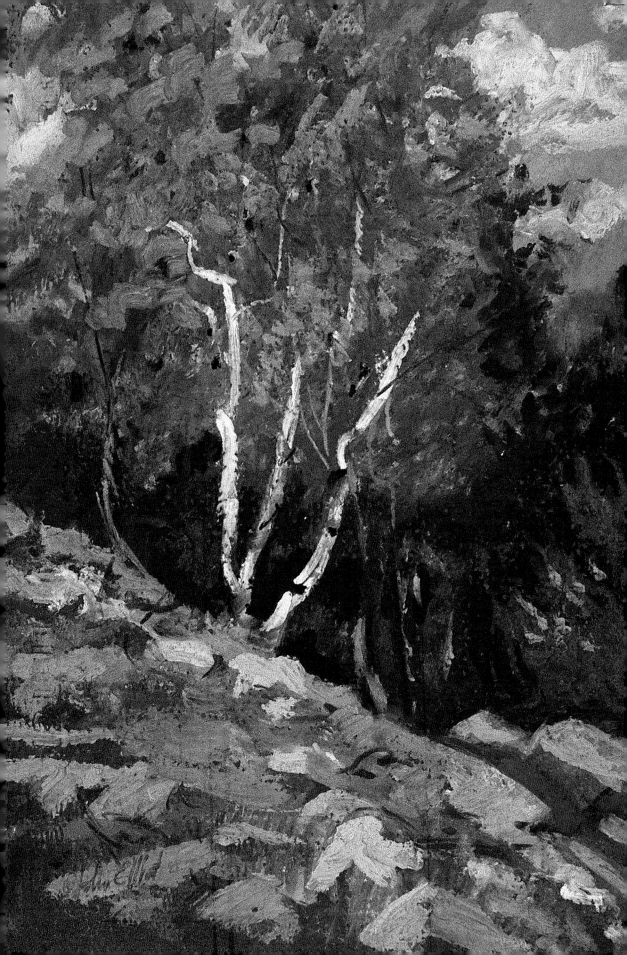

Printmaking Using Oil Pastel with Solvent

After experimenting with oil pastel and solvent, I discovered a way to make evocative, even haunting, paintings with the paired substances. The results are subtle and moody.

The idea is loosely based on the acrylic monoprint process, where an acrylic painting is painted thickly on a nonporous surface such as glass, and then a single printing paper is laid onto the wet image to pull a reverse monotype. My technique substitutes oil pastel and solvent, then uses pastel paper as the printing "plate."

I begin by painting a composition on sturdy paper, using oil pastel applied more thickly than usual. Then I sponge an etching paper or a printing paper such as antique velum by Stonehenge with solvent, and quickly press the solvent side down into the thickly painted original.

The upper layers of the thick oil pastel adhere to the print, making a moody reverse of the original painting. Most of the pigment stays put on the original painting, although I may have to touch it up a bit with more oil pastel here and there. Once that's done, I have a unique double portrait: the bold original and a subtle, reverse portrait printed from it.

I especially like this method applied to portraiture, but try it with any subject matter. A serene landscape by day versus a moody moonlight scene comes to mind. For any creative thought crossing your imagination that offers mood contrasts, this technique will give you a means to express it.

BIRCHES
Oil pastel on pastel paper, 12 × 9" (31 × 23 cm).

A heavily painted oil pastel like this landscape is a perfect candidate for use as a "plate" from which to produce a print. This process of mine gives you two works of art from one creation: your original painting, plus a reverse print made from it.

Demonstration:
Portrait Plate and Print

Your oil pastels should be on the medium-hard side, as too soft and creamy might blur and spread under the pressure and solvent combination. Again, be sure to work with adequate ventilation when using a solvent such as Turpenoid, and to wear protective gloves.

In fact, if possible, I suggest that you at least practice this technique using artist-quality water-soluble oil pastels. Then your solvent, being ordinary tap water, is completely safe.

Step 1: Heavily painted original. As with this portrait, your original must be painted very heavily with oil pastel. Make sure the upper layers are what you want to print; the slight thickness of the upper layers in general prevents the under-layers of oil pastel from reaching the printing paper. For example, I do not expect the background green to print. That is a color excitement in the original that I purposely plan to be absent in the moody print. However, I want the viewer to focus on the green eyes in the print, so I make sure to apply plenty of green oil pastel to the iris of the model's eyes.

Step 2: Sponging. The most practical way to apply solvent is to sponge it liberally all over your printing paper—but not so much as to make puddles of liquid. You can quickly soak up excess solvent with blotters or absorbent newsprint. The printing paper used here is actually pastel paper (smooth side) since I wanted a dark color.

Step 3: Transferring the image. I lay the printing paper over the original and use the pressure of a spoon to transfer the image. By using a spoon and steadying it as I apply pressure, there is no movement of the printing "plate" and thus, no chance of smearing the print. However, I have also successfully used a heavy brayer and an etching press for the job.

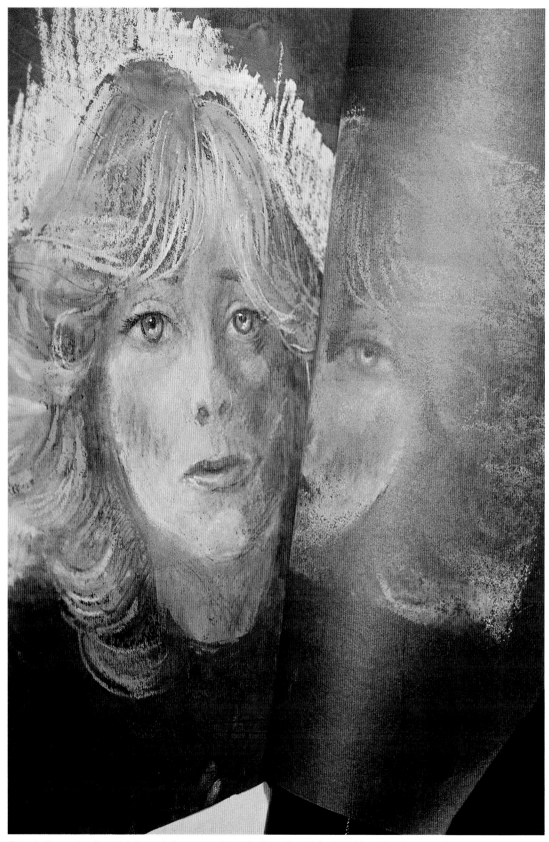

Step 4: Removing the print. I carefully remove the print from the original thickly painted paper plate.

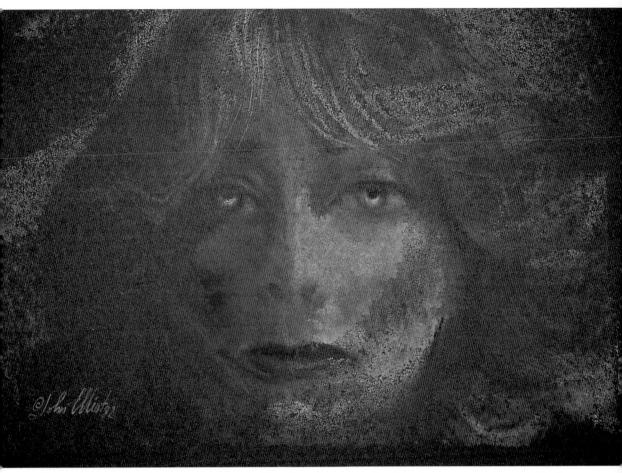

Step 5: The print. Here is the moody print pulled from the original. Note that it is, of course, a reverse print. Whether sponged with solvent or water, the print will need a well-ventilated area in which to dry. Hang it by two corners so that front and back dry at the same time.

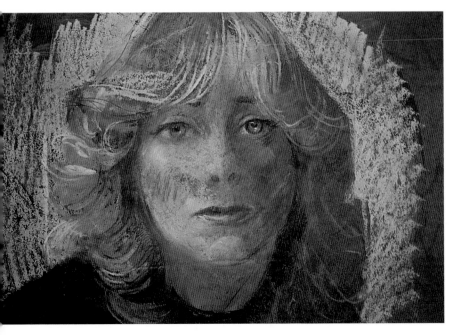

Step 6: Original painting after the print was pulled. Note how much of the face has migrated to the reverse print. I will repaint areas of the face, but will not enhance the green eyes, having reserved that effect for the evocative print.

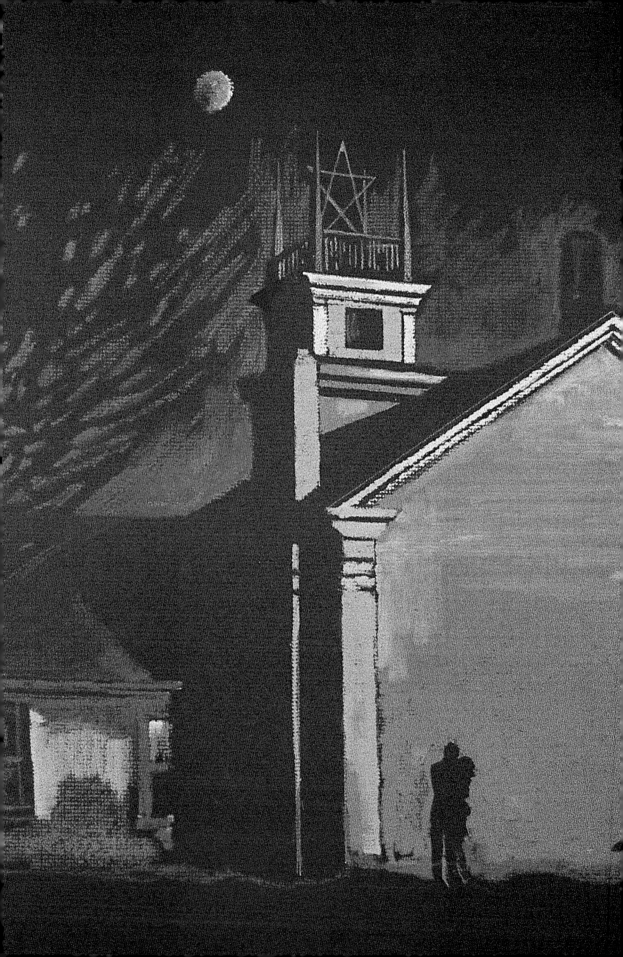

Afterword

This wraps up our excursion into the wonderful world of oil pastel painting. You may have started out as a beginner and stranger to the oil pastel medium, but now you should feel at home with it.

After you master the processes and techniques in this book, you will be truly entitled to present yourself to the world as a knowledgeable and competent oil pastelist. Be proud of your new skills. You may even find that you are eager to delve into more advanced oil pastel techniques. I have devised many and continue to explore new ways to use oil pastel, which I hope to present in a future book.

Finally, remember, when choosing subject matter for your oil pastel paintings, unless you have an emotional reaction to a scene, just move on until you come upon something else that does inspire you. You'll find that somehow, your excitement with what you see will be reflected in the painting you create. That's the difference between a factual rendering and a meaningful work of art.

Paint and enjoy!

John Elliot

THE KISS (DETAIL)
Oil pastel on museum board,
16 × 20" (41 × 51 cm).

I painted this Vermont church in the last rays of the setting sun. It began with a drawing of the lovers in my sketchbook, then developed into a painting back in my studio. I thought that this was the most tender and touching scene of my painting excursion that winter.

Framing and Shipping Tips

Never use a hot press to attach an oil pastel painting to a backing. Some framers routinely handle works on paper with this technique. Use of heat in this manner can melt the oil pastel's binder, causing damage to the work. Instead, if a backing is needed to support an oil pastel painted on paper (as opposed to museum board or other rigid self-support), the painting may be affixed to a board with artists tape or mounting triangles.

Although I sometimes use spacers alone to separate an oil pastel painting from the glazing that will go over it, I frame most of my oil pastels with mats. Glazing should always be used to protect oil pastel artwork. Glazing may be either glass or acrylic (the Plexiglas brand is the most common acrylic used). Unlike dry pastel, oil pastel does not produce dust that will be attracted to the static buildup that occurs under acrylic. Try to avoid "nonglare" glazing. Like sunglasses, these coverings will obscure some colors. And in choosing a frame, the decision is purely an aesthetic one. An oil pastel painting may be safely framed in wood, metal, or plastic.

NEVER USE FIXATIVES

Even though fixatives and varnishes are used by some oil pastelists for special effects, I strongly believe that they have no place with this medium. Oil pastels painted in the techniques covered in this book will not need fixative.

Paradoxically, some well-meaning framers destroy oil pastel paintings by spraying with fixative or varnish, which can discolor and even dissolve oil pastel. With self-fixed oil pastel, what you see is what you get. The surface texture and colors will remain as you painted them. So if you take your paintings to a frame shop, be sure to alert the person who takes your order that fixative or spray is not to be used. You might even ask for that statement to be recorded on the receipt you're given when you place your framing order.

VIEW FROM THE GRANGE
Oil pastel on museum board, 30 × 40" (76 × 101 cm).
In this painting, I wanted to capture the fresh feeling of a southern Vermont meadow as seen from the interior of the historic West Arlington Grange building. I used oil pastel very sparingly, except for the meadow scene. This focuses the viewer's eye straight to that scene.

SHIPPING OIL PASTELS

If you need to ship an oil pastel painting, plastic glazing is preferred. If you ship glass, use the professional's practice of liberally crisscrossing the glass with masking tape. Then if anything cracks, pieces of glass are less likely to make a jabbing move and tear the painting underneath. Of course, use plenty of packing material and an oversized crate or double carton; that is, pack the painting in one carton, then pack that carton in a second larger carton, with its own padding material. You might also consult a local museum for shipping advice.

HUDSON IN AUTUMN SERIES, VI
Oil pastel on aluminum plate,
5 × 7" (13 × 28 cm).

When an oil pastel painting is framed with a mat, the glazing touches the mat, not the painting, which is safely recessed behind it. The choice of frame is purely an aesthetic one. In this case, an ornamental gold frame picks up some of the golden-yellows in the painting and complements the richness of the landscape.

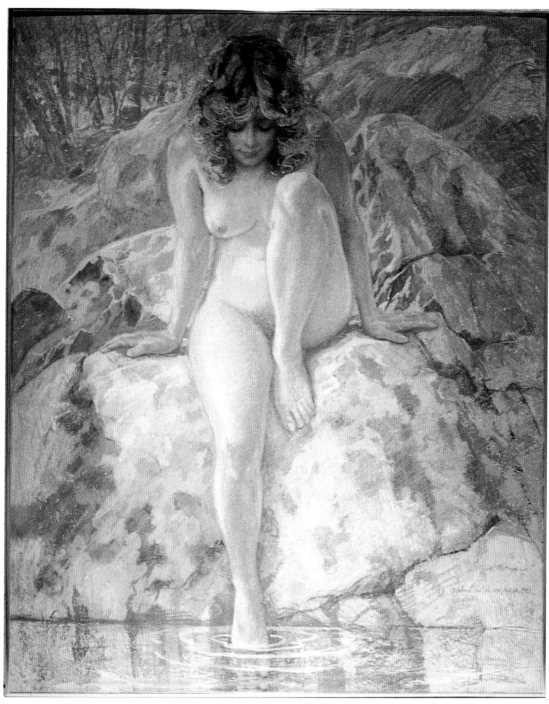

QUIET MOMENT
Oil pastel on museum board,
40 × 30" (101 × 76 cm).

Although I usually frame my oil pastels with mats, occasionally I feel a painting looks better unmatted. The delicacy of this painting's palette and the serenity of the scene called for the simplest frame possible, to take the viewer right into the intimate moment portrayed, without a mat or elaborate frame to divert the eye. When a mat is not used, I insert spacers to prevent the glazing from touching the painting surface.

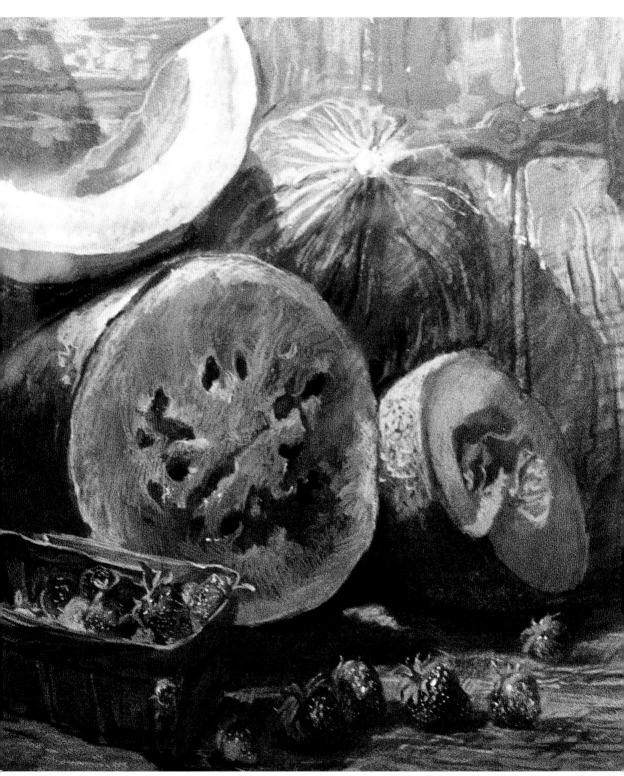

MELONS
Oil pastel on pastel paper,
24 × 20" (61 × 51 cm).

Oil pastel was the perfect medium for this award-winning still life. It allowed me to express the many colors and textures of the fruit and weathered wood.

About the Author

John Elliot was born into a family of Scottish statesmen. When he was just four years old, he was given his first pastel stick and proceeded to amaze his family, their friends, and visiting dignitaries by sketching a remarkable likeness of one of the guests.

During his formative years preceding World War II, Elliot traveled with his family extensively over much of Europe and the British Empire. Recognizing the boy's talent, the family exposed him to the great paintings of Western Civilization in museums and private collections, and young Elliot was so inspired that he sketched and painted constantly. Although he worked in oils and watercolors as he grew older, as part of a traveling family, he found that a box of pastels and a few sheets of paper were the most practical tools for an artist on the move. Hence, many of his earliest works were pastel paintings.

During the postwar years, as a young adult, Elliot became involved in the recovery of artwork that has been lost, particularly in Italy—another visual treat for a practicing artist. In studying those great works, his devotion to the versatile pastel medium continued to grow as he discovered both the refined finish of a formal Vigée-LeBrun portrait and the loose spontaneity of a Mary Cassatt portrayal of mother and child.

After he settled in the United States, Elliot's talents and versatility branched into several areas of the arts, including an award-winning career in film production/design. By the 1980s, however, his focus turned principally to oil pastel. He wrote articles and gave workshops and demonstrations for teachers, writers, and students; made early instructional videos; and founded the Oil Pastel Association to spread the word among artists and collectors. He also served as a consultant to manufacturers, to help them understand what their new oil pastels could do. As a working artist, he was able to gauge the good and bad qualities of a formula more readily than the scientist in the lab, and took great pride in being able to further the cause of art and artists in the development of the versatile oil pastel medium.

Today, after seventy years of an intense love affair with art, Elliot is as active as ever. He continues to paint every day—either on location or in his studio. With the publication of this book—a collaborative effort with his wife, Sheila, whose writing and organizational skills were integral to the project—John Elliot now enjoys sharing his passion for oil pastels with a wider audience than ever.

John Elliot poses by an oil pastel portrait he created, inspired by a painting he had admired in the Tate Gallery in London, entitled *General Elliot Accepting the Keys of Gibraltar*. The Elliot of the painting is an ancestor of the artist.

Resources

Listed below is contact information for the author and for an association founded by him whose membership is devoted to the art of oil pastel.

To try the many techniques and materials featured in this book, you can obtain oil pastels and related products at numerous art supply stores across the United States and in other countries. Some of the larger retail outlets and catalogs are listed below for your reference. A trade association that represents manufacturers of art materials is also listed, as are the three major manufacturers of pastel brands described in this book, and three manufacturers of painting surfaces particularly suited to oil pastel.

AUTHOR, ASSOCIATIONS

John Elliot
304 Highmount Terrace
Upper Nyack, NY 10960
(845) 353-2483
mail@JohnElliot.com
www.JohnElliot.com

Oil Pastel Association
 International, Ltd.
John Elliot, President
Grand Central Station
P. O. Box 20459
New York, NY 10023
(845) 304-6988
mail@OPAI.org
www.OilPastelAssociation.org
 (founder's site and history)
www.OPAI.org (digital-slide
 registry and links to
 international and regional
 associations)
www.OilPastel.org (first OPA,
 now run by Dorothy Coleman,
 Executive Director)

The Art & Creative Materials
 Institute, Inc.
1280 Main Street, 2nd Floor
P. O. Box 479
Hanson, MA 02341
(781) 293-4100
debbief@acminet.org,
www.ACMInet.org (safety-
 certification association)

MANUFACTURERS OF PASTELS

H. K. Holbein, Inc.
P. O. Box 555
Williston, Vt. 05495
(800) 682-6686
HolbeinHK@aol.com
www.HolbeinHK.com

Sakura of America (Cray-Pas)
30780 San Clemente Street
Hayward, CA 94544
(510) 475-8800
express@sakuraofamerica.com
www.gellyroll.com

Savoir-Faire (Sennelier)
40 Leveroni Court
Novato, CA 94949
(800) 332-4660
info@savoir-faire.com
www.savoir-faire.com

MANUFACTURERS OF PAINTING SURFACES

Ampersand Art Supply
 (Pastelbord)
1500 East 4th Street
Austin, TX 78702
(800) 822-1939
www.ampersand.com

Canson, Inc. (Mi-Teintes)
P. O. Box 220
South Hadley, MA 01075
(800) 628-9283
www.canson.us.com

Strathmore Artists Papers
39 South Broad Street
Westfield, MA 01085
(800) 353-0375
www.strathmoreartists.com

RETAILERS AND CATALOGS

Cheap Joe's
374 Industrial Park Drive
Boone, NC 28607
(800) 227-2788
www.cheapjoes.com

Daniel Smith
P. O. Box 84258
Seattle, WA 98124
(800) 426-6740
www.danielsmith.com

Dick Blick Art Materials
P. O. Box 1267
Galesburg, IL 61042
(800) 447-8192
www.dickblick.com

Jerry's Artarama
P. O. Box 58638
Raleigh, NC 27658
(800) 827-8478
www.jerrysartarama.com

New York Central Art Supply
62 Third Avenue
New York, NY 10003
(800) 950-6111
www.nycentral.com

Pearl Paint
308 Canal Street
New York, NY 10013
(800) 451-7327
www.pearlpaint.com)
(stores in over twenty cities)

Index

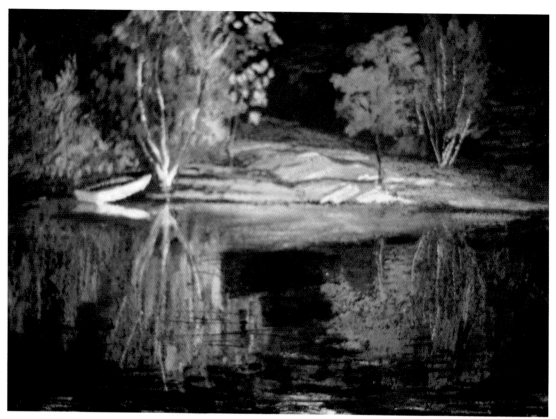

SUSSEX LAKE, SERIES IV
Oil pastel on museum board,
9 × 12" (23 × 31 cm).

To express the stillness of the water, I interrupt the verticals of the reflection only sparingly, using short, horizontal strokes. If there were more definite ripples, I would use more and larger horizontal strokes.